TEACHING AR

Doreen Roberts

B T Batsford Limited London

© *Doreen Roberts 1978*

First published 1978
ISBN 0 7134 0633 X (hardback)
ISBN 0 7134 0634 8 (paperback)

Filmset by Servis Filmsetting Ltd, Manchester
Printed in Great Britain by
J.W. Arrowsmith Ltd, Bristol
for the publishers
B T Batsford Limited
4 Fitzhardinge Street
London W1H 0AH

Contents

leave alone—criticism—atmosphere

Acknowledgment

My thanks to Miss P M Shaw B Sc, Headmistress of the John Howard School, Clapton, London E5, for her permission to publish photographs of students and students' work taken at the school. Also for her support of art department ideas for over twenty years.

To Mr P Hampton BA, BD, M Ed, Principal of the College of All Saints, Tottenham, London, for permission to publish photographs of students and students' work taken at the college.

To those students of the College of All Saints who stated clearly that this book should be written and who encouraged me to do just that.

To Thelma M Nye of Batsford who did much encouraging and had all the trouble of reading and correcting this manuscript. The photographs were taken and processed by the author.

D R, London 1978

Introduction

Here is a reference book for those who teach art, particularly for those with no specialist training. It contains basic information about materials, equipment, class organisation, giving lessons, the sources to which teachers may turn for ideas, and how to develop them.

Everything here has been written either from a long experience of teaching art or as a result of questions asked by students learning to teach a variety of age groups. Some of these students have very little art training and yet will have to handle materials and deal with visual problems in the classroom or studio.

Getting ideas seems to be one of the biggest worries for new teachers where there are no set books to provide the impetus.

Possibilities, beginnings and directions are offered here — as well as suggestions on purely practical matters.

PART 1 MATERIALS

Pencils—crayons—erasers—paper—pens—inks—adhesives—printing inks—dyes—general tools—materials for three-dimensional work—photography: cameras—chemicals—textiles

Artists' suppliers

Do write to all the major companies, not only for their current catalogues but for any leaflets or other printed information that they have to offer on their products. I have always found them most helpful in this and in answering any queries.

E J Arnold issue one of the most exciting, tempting and comprehensive catalogues for an unbelievable variety of crafts.

In addition to their full catalogues of art materials, *Winsor and Newton* have a really good pamphlet, *Composition of Pigments* which tells what is contained in oil colours, water and acrylic colours, their solvents and media, etc. This also gives information on any toxic qualities. Both Winsor and Newton and *Rowney* issue individual leaflets on their water colours, oils, acrylics, inks, etc.

Nottingham Handcraft sell sets of very good slides and other teaching aids. *Dylon International* offer film shows (London), posters for sale on dyeing methods, as well as leaflets on the subject.

When you have all the information possible, get to know which manufacturer sells what; compare products and, where possible, prices, and become familiar with as much as you can. After that it is a question of keeping up with any new developments.

Even if you cannot afford what you want, it is still advisable to keep your information up to date so that you can offer help if needed by the students – and in case money does become available. Find out if your local authority will allow you to specify brands or have what is sometimes called a 'special requisition' for items less general than are on your usual order list. If you have a serious query or complaint, never be afraid to write to the firm concerned.

Most manufacturers have retail outlets unless, like Arnold and Nottingham Handcraft, they are solely educational. Even so, Arnold and Berol both distribute some well-known brands such as *Eagle/Derwent* pencils.

Ordering for school

One of the first problems in management faced by new teachers is what to order and how much. They seem, naturally, very disappointed when no-one will give them a straight answer. This is not evasion. It is simply that every school and each department within it and within the local authority, will have different allocations of money. Each school's art department will probably be biased towards different areas of work (apart from such things as pottery/woodwork) – so that no straight answer is possible. The thing is to ask the head of department (or your predecessor) what was done before, what sort of forms are used – and if possible, get hold of some old forms from the school secretary or whoever holds them. Look at the syllabus – if there isn't one, just find out verbally where the heaviest consumption was. If the bias is the same

as yours, then your order can follow the same pattern to begin with. If you discover, for instance, that you are likely to be doing thirty per cent more drawing, then order the equivalent increase in stocks of paper, if this is economic.

Unless you are to run the department, there will always be someone to ask — but you must not be passive about this.

Once you have started work, keep a record of the amount of materials used — by a class, or age group, in a week or month — any method which will give you a guide until you are experienced.

Suppliers' addresses

George Rowney and Co Ltd
PO Box 10, Bracknell, Berkshire RG12 4ST

E J Arnold and Sons Ltd
Head Office: Butterley Street
Leeds LS10 1AX

Winsor and Newton
Wealdstone, Harrow, Middlesex HA3 5RH

Dryad (Reeves)
Northgates, Leicester LE1 4QR

Reeves
Lincoln Road, Enfield, Middlesex EN1 1SX

Berol Ltd
Oldmedow Road, Kings Lynn, Norfolk PE30 4JR

Nottingham Handcraft Co Limited
Melton Road
West Bridgford, Nottingham NG2 6HD

Dylon International
Sydenham, London SE26

Pencils, crayons and erasers

Most people know very little about pencils and what they can do. More often than not they are used casually if a ball-point is not available. Even for drawing, the majority of people pick up the first one available – either from laziness or lack of knowledge.

Pencils

Beautiful and versatile tools; they can make thin delicate marks, fuzzy grey ones, rich velvety ones. The softness and hardness of pencils is designated by numbers which range from 8B (very soft) to B and through H to 8H (very hard). The harder the grade, the thinner and greyer the maximum density will be. An 8B will make soft dark marks and will be very smudgy. An HB is in the middle and is what you will receive if you just ask for 'a pencil' in a shop. 2B–4B are most popular for drawing. 2H–6H are used in preparing grids for designs or for lettering where guide lines have to be very faint and are sometimes not erased.

Apart from graded pensils, there is the soft, ungraded type with a fat lead, given different names by different manufacturers. *Black Prince, Black Beauty* are two of them. Some local education catalogues call them *Lead Beginners*. They are really made for young children who are learning to write.

Berol make two extra soft pencils like these. They make beautiful soft marks and feel like silk over the paper – but the softness does not refer to wear. Both types are chemi-sealed and very strong. The *Alphex* has a slightly larger hexagonal thickness and the *Draughting* pencil is a 'transition' pencil between the beginners' type and the graded ones.

Carpenters' pencils are lead pencils with a flat section which can be useful for lettering. They are usually graded soft, medium, hard.

Willow charcoal comes in boxes of thick or thin sticks. It does not make a rich black and when rubbed, tends to smear off the paper.

Charcoal pencils are wooden pencils with charcoal in the core instead of graphite. Grading varies according to the maker/importer. For instance, Rowney supplies 'medium' degree, Winsor add 'soft'. Otherwise they are graded as pencils but there is a very small range – perhaps four grades.

Crayons

Conté crayons are available in small boxes of square sticks or in pencil form. In stick form the colours are black, white, sanguine (brownish red). They are usually graded medium, soft, extra soft. For young students and general use, this medium is extravagant and it is better to use stick charcoal (willow).

Pastels are made from finely ground pigments and they work like very soft chalks – easily breakable. These are known as 'artists' pastels and

Greasy crayon

Black and white pastel

are expensive. However, the 'scholastic' pastels in Reeves' catalogue are tougher, like hard chalks – and therefore better for school use. These are also called *Greyhound* pastels. The black ones are a rich velvety black and smudging can create interesting effects against a crisp line made with the edge of the stick.

All pastels, chalks etc are easily smudged, so must be fixed by spraying the surface with what is called 'charcoal fixative', although this is suitable for fixing soft pencil work as well. It can be bought in aerosol cans or in bottles with a blow spray (sold separately). The latter method is cheaper but wearing on the lungs. In either case it is better to use several fine coats of spray rather than one concentrated one, as this often saturates the drawing and makes the chalks run.

Wax crayons are usually thick and come in rather crude colours. Some manufacturers are extending their range, and this particular commodity is developing rapidly. These crayons are very good for bold wax resist methods in painting and they are not too expensive.

Oil pastels are versatile and, again, come in different ranges of colours depending on the manufacturer. Like wax crayons, an increasing number of makes is becoming available. They can be used as drawing tools in their own right or for a more subtle approach to wax resist effects. They can be overlaid and mixed – makes like *Neocolour* and *Sakura* are particularly good for this. *Talens' Panda* are thicker and slightly greasier but work well. Neocolour may be sharpened in a holder.

13

Coloured pencils come in various colours and there are some which can
be moistened or washed over with water to give a water colour effect –
although with most of these the pencil lines still show through the wash.
All these are *pencils* and therefore are more naturally suited to linear
work and more conventional techniques. There are too many varieties
to list and catalogues do give enough information.

Erasers

For normal use, plastic erasers are far more effective than rubber. They
rub out more cleanly and will also erase the smear which usually appears
when lead is removed from tracing paper. *Rotring* and *Staedtler* are the
best known makes but there are more now appearing on the market.
A putty rubber is not really a rubber in the true sense. It is a kneadable
lump with tacky qualities which when kneaded to softness, will lift tiny
areas of pencil work from a drawing. It used to be used for picking out
highlights. If you actually try to rub with it it will leave grey, dirty
smears – it is not an eraser to have unless there is the special need.
Even then, I have found that a tiny sliver cut from a plastic eraser will
'spot erase' more effectively.

Paper

The majority of papers can be used for most things if the one most suitable for the job is not available. In emergencies, newspaper can be used for painting at any age level. If it is crumpled it can be ironed smooth. The main characteristic to remember is that it is very absorbent and needs to be used with well controlled paint – this can be used deliberately to help beginners to mix their paint thickly enough. (If it is too thin, the print will show through.)

For other economy measures try –

Shelf paper from stores or hardware shops – crisp, semi-transparent. Among other things it can be used for screens for shadow puppet plays. It is also very good for layout – the arrangement of various parts of a design (or lettering) where, by seeing through the paper, the components of the design may be placed in different positions before a final decision is made.

Old posters and stop-press sheets It is well worth while making friends with your newsagent as he may be only too pleased to let you have these when they are no longer of use to him. The reverse side is usually plain, but if not, it will still be good for paint, collage, or for anything which will ultimately cover the whole surface.

Brown paper etc, from school requisition parcels – often the equipment is double wrapped – is another source of supply.

Paper sizes

All papers come in graded sizes which have replaced largely Imperial measurements and now conform with European standards; these are known as the 'A' and 'B' sizes. For example:

A1 =841 × 594 mm =$33\frac{1}{8} \times 23\frac{3}{8}$ in.
A2 =594 × 420 mm =$23\frac{3}{8} \times 16\frac{1}{2}$ in.
A3 =420 × 297 mm =$16\frac{1}{2} \times 11\frac{3}{4}$ in.
A4 =297 × 210 mm =$11\frac{3}{4} \times 8\frac{1}{4}$ in.
A5 =210 × 148 mm =$8\frac{1}{4} \times 5\frac{7}{8}$ in.

Quantities Quire =250 sheets Ream =500 sheets

Weight means thickness but this is not often referred to in school stock lists. As a guide, a *good* drawing/painting paper would be of 150 g/m^2 (72 lb) or more. The higher the number, the thicker the paper. If you can familiarise yourself with one or two weights then you should be able to assess others by comparison.

Tissue paper, overlaid

Cut paper

Types of paper

Cartridge paper is made in a variety of weights and qualities. It is an all-purpose paper, white cartridge being most useful across a wide spectrum. It will take pencil, all graphic tools, inks, crayons and paints – except oils. It will cockle if made very wet, although it may first be stretched and dried on a board to prevent this. This is not likely to be necessary in school, except for advanced work.

Pastel/brushwork/sugar papers are all very similar. They are slightly rough and fairly absorbent. These give a good grip for chalks and similar media, also for powder/poster paint. Some manufacturers make them in thin, medium and thick grades – no weight given – and in assorted colours. Neutral-coloured sugar papers work well for painting or as backgrounds to a set colour scheme.

Kitchen paper is a thin, crackly, beige paper. It is good for rough work and for general 'dogs-bodying'.

Newsprint is newspaper without the printing. It is absorbent and soft. Good for potato cuts, printing, rough work and preparing designs for photograms.

MG (machine glazed) or Litho paper This is expensive. One side smooth and one rough (choose for the job in hand). The smooth side is beautiful for pencil work. In fact it is marvellous for almost anything except a really wet medium, then it cockles.

Tracing paper is purpose made (also for overlays). It comes thick or thin. Good quality tracing paper is milky. The cheaper qualities are almost crinkly, like greaseproof and not very transparent. It is a good idea to keep some of each quality so that the best is available for special jobs but is not used all the time.

Coloured papers These are real luxuries and there are so many types that going into details would be impractical. Apart from the range of standard favourites (coloured cartridge, Ingres, flint and laid papers etc) it is possible to buy packets of 152 mm squares which are gummed and useful for small work.

Foil papers Luxurious but useful for decorations and similar work. They are metallic papers with a bonded white backing. Used in tiny amounts they will give sparkle but can look crude if used in large amounts.

Tissue papers The number of colours available through local authorities is usually limited but if bought from a supplier, you will have much more choice. Tissue paper is especially good for stained-glass designs and for demonstrating overlapping tints. The colours fade if exposed to bright light for long. They run if made wet, so don't use water paste. Minute dabs (pin head) of PVA or a similar adhesive will work well.

Acetates Plain or coloured, totally transparent. Good for overlays and for optical effects. Join surfaces with double-sided tape or a quick-bonding, transparent adhesive. Choose glue with care – some dry slowly and others eat into certain plastics.

Paints

There is such a wide range of types of paint that it is essential to obtain manufacturers' catalogues in order to be well informed. Also, the variety of trade names can be confusing. Whether to buy powder, tube, block or liquid colour must depend on individual circumstances. Unless you are starting from scratch in an entirely new school, there will be some sort of ordering pattern already established, so it is a good thing to go along with this before deciding whether to retain or change it.

Powder colours

These are the cheapest and best for bulk buying. The powder mixes with water to the required consistency – 'double cream' consistency for full opacity and saturation of colour. They contain little or no fixing agent so will tend to rub a little and flake off smooth surfaces. They are usually supplied in tins of 500 cc or 1000 cc capacity. Plastic plates on which to mix colours are cheaper than purpose-made palettes. Small plastic containers are needed to hold supplies of colour.

It is a matter of choice, but students can be·given a limited number of colours from which to mix others and their supplies can be shared or not as you wish.

The 'cake-tin' design for holding powder colours is most popular but takes up a lot of room on a table. Arnold make a good variety of containers and Berol make a tray which holds 8 plastic pots with lids – which helps to prevent spillage when moving them and makes for clean storage.

Block colours

These are more expensive and sometimes need a good deal of rubbing with the brush to gain richness and thickness. Basically, these are powder colours pressed into blocks. Their chief snag is that one colour gets carried into another very easily.

Poster colours

These are finer-ground colours, mixed with gum to adhere to paper. They are supplied in pots or tubes and are inclined to harden if not used regularly. Colour in pots can be reconstituted with a great deal of effort and distilled water. Bore holes into hard paint with a knitting needle and cover with the water – when soft enough mix thoroughly. Try storing the pots upside down when not in use, the paint forms an air-tight seal against the lid.

Redicolour

This is one trade name for liquid colour in squeezy bottles. It is economical and can be used for simple printing techniques as well as for painting. The colour tends to separate from the liquid in the bottle if left and tends to harden round the cap.

Designers' gouache

This is expensive, finely ground, and mixed with gum. It is supplied in tubes. There is a wide range of colours, they are opaque, reliable, versatile — and used by professional designers. The price of the colours varies. There are usually three price groups. Use straight from the tube or dilute with water.

Acrylic/Polymer/Cryla

These are trade names and descriptions of 'plastic' colour. It is pigment based with acrylic polymer resin — synthetics — which give good adhesion to almost any surface, without the need, as with oils, to prime the surface. They are not imitations of oil colours but may be used in similar techniques, with no need for turps or linseed oil since they are water soluble. When dry they are permanent and waterproof.

On first application there is a tendency to be slightly transparent, but additional layers will cover. They can be used with polymer texture paste or very thickly by themselves — or in transparent layers.

Warning Do not let the paint dry on the brushes — keep the latter in water. If brushes dry off by accident it is possible to save them if they are left in methylated spirits overnight before rinsing and cleaning. Don't let the paint dry on your clothes!

Substitute Mix ordinary powder colours with *Marvin Medium* (or alternative) slightly thinned to requirements. For further information on Marvin see *Adhesives*.

Use plastic palettes, china plates, enamel campers' plates or sheets of plate glass as palettes for mixing colours. If the colour dries on any of these surfaces it can be peeled off or soaked with meths.

Rowney publish a booklet *Painting with Acrylic Colours* by Alwyn Crawshaw which is useful.

Minimum range of colours

This applies to all types of paint, not just to powder colours.

Black, White (always buy more of this)

Lemon, Golden yellow (makers' names vary), Yellow ochre.

Vermilion or its equivalent, Crimson

Ultramarine, Prussian blue, Turquoise.

For luxury add Magenta, Emerald, Purple. These can be mixed but are richer and clearer when bought.

The names of many colours vary according to manufacturers but these are the familiar ones on which to base purchases.

Brushes

Flat and round ferrules

For general, non-specialist work (also with acrylic paints) Hog-hair – long bristles, it is better to buy thick than thin. Short-haired brushes are available but these wear out more quickly and if paint is accidentally left in the bristles they are quicker to splay than the long-haired ones. Brushes are supplied with straight-cut (chisel) edges and almond (filbert) shape – both of these have *flat* ferrules. *Round* ferruled brushes are referred to as *fitches*.

Sizes are numbered and numbers vary with makes, so consult your catalogues. *Soft-hair brushes* vary in material and quality. Sables are the most expensive but with care will retain their spring and the point and last for years. Hog-hair brushes are tough enough to handle powder and school type paint, but sables are best kept for finer jobs. If coarse paint is used, then do the mixing with a tough brush and only apply the paint with a soft one.

How to choose a sable fitch Always ask for a pot of water. If the shop is a specialist art shop catering for serious workers, then one will be available without question if it isn't already there.

1 Swish the selected brush in the water to remove all traces of gum which will have held the point in place.

2 Shake the water out of the hairs.

3 Flick the tip of the brush briskly across your thumb nail several times. You should be able to feel the springiness – if not, and if the brush does not show a *perfect* point with no more help than this, try another and another. . . .

If you allow yourself to be intimidated into buying a poor brush, then you are wasting your money and should stick to large work and hog brushes! A good all-purpose size would be a no. 7 and is *very* expensive. Sables also come in flat, thick ferrules which don't have to be tested and which are graded like decorating brushes – 13 mm, 19 mm, etc. These are useful for broad areas. With sables, as with hog, it is better to buy slightly longer haired ones. *Very* long haired brushes are for specialist jobs like lettering.

When buying sables in quantity on requisition it is not possible to test the brushes – but these are not usually of the best quality. There is always a difference between personally selected tools for one's own use and bulk-buying for schools.

Inks, pens and dyes

Many students think of dip pens as being things of the past – that is, if they have even heard of them. Few people use such pens these days except for drawing and it is becoming increasingly difficult to obtain nibs – so it is essential for general art purposes to accustom students to the use of other tools for applying inks or dyes as drawing media.

Tools

Dip pens for straight drawing
Cotton buds from a chemist
Soft brushes of all sorts
Sharpened sticks of wood – these make very small/short marks but hold more liquid as use saturates the wood.
Small sponges
Strips of sponge rubber bound into split sticks
Lettering nibs which make broad marks/strokes
Music nibs which make multiple lines
Nibs for dip pens are still available from Gillot – no 303.

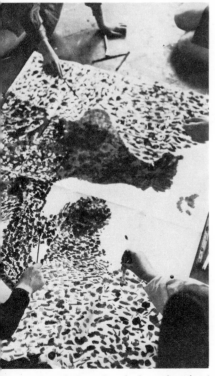

Using home-made and other tools with ink

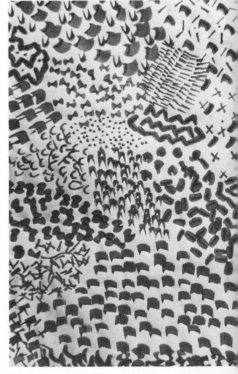

Ink marks made with various tools

21

Self-inking tools

Felt markers Black is the basic colour but there is a wide variety of colours available if you have the money.

Fibre tips/nylon tips These are all variations of the same sort of tool. At least one manufacturer makes a stable range of colours in both thick and thin points – but these are expensive.
Check for those which are or are not waterproof.

Ball-points are useful and surprisingly versatile when used with some imagination.

Inks

Ordinary fountain pen inks are transparent and are easily diluted with water to make washes. Most of these inks are not waterproof, but this is indicated on the label.

Indian ink – black This contains lacquer and is waterproof when dry. When diluted with water it becomes brownish. If allowed to dry on the brushes it will make the hairs brittle.

Drawing inks These are made by a number of manufacturers and come in a large variety of colours. It is economical to buy larger sizes. They will dilute with water, mix with each other and are waterproof when dry. Most are transparent, apart from those made by *Pelikan* which are called 'special' – these are thickish and very strong in colour. Take care when buying *Rotring* inks as some of these are for use with special technical drawing instruments. A catalogue or good shop will solve this problem for you.

White ink dries out in the bottle quickly as the powder separates from the liquid and sinks to the bottom – unless it is shaken frequently it will not be useful for long. A substitute can be made from powder paint mixed thinly and then fixed afterwards with any charcoal spray fix.

Dyes

Dylon International make good dyes which can be used as drawing liquid if made up to the right strength. There is a leaflet available where you buy your dyes (or write to Dylon) which will tell you how to prepare the dye. Mix the concentrated amount hot and when it has cooled it may be stored in jars with lids and used with pens, brushes or any other tool. Take care not to get any on your clothes. Cold water dyes are easier to mix but are less strong.

Natural dyes It is best to get a book on the subject as this is a fairly specialist subject.

Yoghurt containers make good individual pots, but stand them in a plate or dish in case of spillage. This precaution will also help where small bottles of ink are used.

Adhesives

Pastes are cheap. They suit all kinds of paper. Try *cold-water paste* in bags which is obtainable from hardware stores, if not on requisition. It is quick and economical to mix but does not keep long, in a day or two it begins to smell terrible and go mouldy.

Polycell similar in use to the above, but more difficult to assess amounts, as it has to be left for fifteen minutes after mixing while the granules swell – neither is it so easy if you need some in a hurry. On the other hand it will keep for weeks.

Polymer glue/Marvin medium/PVA These are trade or type names for the same sort of adhesive. It is extremely useful and economical, obtainable in all sizes and types of container from the squeezy type cylinder to a 1.125 and a 4.5 litre container.

It is an excellent all-purpose glue which is indispensible. It sticks almost anything, including polystyrene without eating into it. It is a thick white glue which dries transparent, and is therefore ideal where glue might show – when sticking tissue paper or net fabrics, for instance. Use pin-head dots at frequent intervals. Discourage students from using great dollops. It does not stick plastics together as these exclude air and this glue needs air in order to dry. It can be diluted with water and used as a medium for powder paint, producing the equivalent of Cryla/Polymer colour.

Warning When dry, this glue is virtually unremovable from clothes etc. With difficulty, it can be removed from brushes and palettes with methylated spirits. The tops of some of the containers are hard plastic and if any of the glue dries round them, they are difficult to open. So always see that the top of the container is wiped clear after use.

Decant small amounts of this glue into polythene containers with lids (Berol). If the glue dries in this sort of pot, it can be peeled out when totally transparent.

Copydex This is a white, rubber-solution adhesive bought in tins, jars or tubes. It is quick-drying so that it is good for mounting work. Excess glue can be rubbed away but make sure your fingers are clean or it will leave dirty smudges. It sticks paper, card and material (use sparingly on the latter – it can seep through the weave). It can only be removed from clothes with lighter fuel (petrol) and even this may not be totally effective.

Cow Gum Similar to Copydex, except that it does not dry as quickly. This can be an advantage, enabling one to slide the components of a design about until their position is determined. Both Cow and Copydex are petroleum based and should not be used with any of the new resin-coated photographic papers. Cow also gives off an inflammable vapour and should not be used anywhere near a naked flame. It is soluble in lighter fuel so items may be removed long after it has dried. Although both glues are available in tubes, these are prone to seep and you may consider it more economical in the long run to buy a jar or tin.

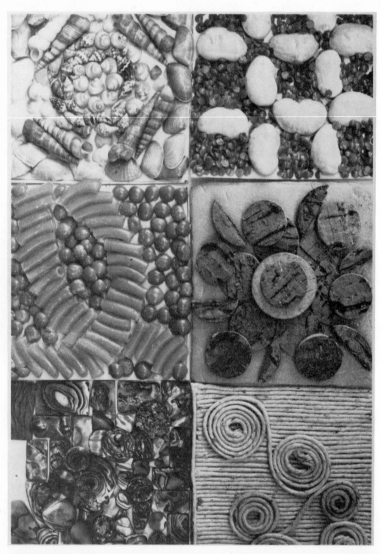

Using PVA glue

UHU comes in tubes, large and small. It is very sticky and again, prone to seep (the largest tube is the greatest offender and this glue may be more economical bought in smaller quantities). However, it dries quickly and is good for fabric collage and for model making since it dries clear.
Bostik This comes in different types for different jobs, so get a leaflet from your hardware shop or from the makers. The 'ordinary' sort is fatal

24

or fantastic (according to your intentions) for burning away great holes in polystyrene.

Balsa cement is for use with balsa wood – it comes in small tubes. If balsa is to be stuck with other materials then use Uhu or Polymer.

Spraymount/Photomount Both by the makers of *Scotch* products. They come in aerosol cans and are extremely expensive, so you are unlikely to use them except for special exhibition work. Spraymount is for thin papers and Photomount for heavier work. I found that the former did not hold well unless the work to be mounted was *very* thin. The latter seems to be the best buy. Place the work face down on old paper, much bigger. Spray evenly. The adhesive is the stickiest to touch that I have used, so take care when picking up the work in order to place it on the mount. Permanent work cards and such things would probably warrant the expense. It lasts a long time.

Scotch Tape now comes in different types – for instance there is a double-sided one, with one side tackier than the other so that the tape can stay in place and work be replaced, or work remain while the whole tape load is removed to another location. All reels of tape have specifications on the wrapping (or in the catalogues) so that you can choose the right one for the job.

Printing inks/dyes

Block printing inks come in fairly economical large tubes in basic colours. They can be mixed together with a palette knife and are effective in producing textures of overlaid colours. They are much less expensive than lino inks (both are water-based) but they have the disadvantage of drying very quickly in hot weather so that it is difficult to get good prints.

Lino inks which are water based, are less economical.

Lino/Fabric printing inks (oil-based) These are more expensive but are richer in effect and are not so acutely affected by temperature. However, they do have to be cleaned with turps substitute and this can be difficult unless students are not only well trained but reliable in clearing up.

Hint: scrape ink off palette so that hardly anything is left, then use newspaper dampened with turps substitute for all but the last clean wipe. Roll the rollers on to paper too to get rid of excess ink.

Economy For some types of printing, and you must do your own experiments, try powder colour mixed with thick Polycell. The effect will be slightly textured.

Dylon (made up) When cold it can be poured onto foam rubber pads in saucers and used for potato prints or any stamping method. Use cold for batik, hot for tie-dye.

Dyes and household bleaches can be painted on to paper for 'one-off' designs.

General tools

Rulers It is useful to have half- and full metre ones for measuring, but metal-edged ones for cutting.

Medium-size set squares These are essential for making sure that mounts, etc, have accurate right angles.

Wire cutters (snips) Have at least two pairs.

Pliers General purpose – have at least three.

Hammers One medium and one heavy.

Pincers If you have wire cutters, then one pair of pincers should do.

Flexicurve This is lead core of varying lengths covered with PVC. It can be bent and curved as you wish. It holds its shape until pushed out of it and is very useful for drawing identical curved lines and in general design. Made by *Unique Slide Rule Co*, Newhaven, Sussex.

Knives

For general and heavy work use the *Stanley knife* with a good supply of retractable blades.

Exacto Small craft knife with replaceable blades which blunt rather quickly.

Scalpels Excellent for delicate work or when you want something really sharp. Replacing the blades is not easy and could be dangerous – don't let the students do it. The blades are fragile so will snap with any real pressure, but don't be put off. Have at least one scalpel with extra blades (straight edged ones are better than curved). Ask to see the range of handle and blade shapes at the art suppliers'.

Tapes

Sellotape Various widths but this will not take paint.

Masking tape will take paint with some persuasion. The tape peels off surfaces and is less adhesive than *Sellotape*.

Brown gummed paper Used for masking screens for printing and for stretching dampened paper on a board. Use water rather than lick.

Double-sided Sellotape and Scotch Tape are mentioned in the *Adhesive* section.

Scissors tidy boxes Obtainable from E J Arnold and have holes to hold 48 pairs.

Brush racks with holes to hold brushes the right way up are available from Reeves.

Pencil racks used to be available although I can find none in present catalogues. It is possible that these could be made very easily in the woodwork department.

Sundry materials for three-dimensional work (other than clay/pottery)

Papier mâché
Method
1 Tear up newspaper into tiny pieces and soak them overnight in cold water paste. Squeeze out excess moisture and you will be left with handfuls of soggy modelling medium. This will take a long time to dry out and will shrink — so make allowances for both.
2 Over a base of some sort, according to the job in hand, paste alternate layers of plain and printed newspaper put on in very small pieces or strips. This layering ensures that you can see that every one is complete. If the base has to be removed afterwards, then it must be greased lightly first. This method can be used over a chicken wire base as well. Seven layers of paper will be rock hard when dry. Make sure that the last layer is well soaked with paste and smoothed off well.

Plaster of paris
Add powder to water (work *very* fast) until of a thick creamy consistency. Remember to grease moulds or objects first and blow gently on the plaster as you pour it in, so as to remove air bubbles.

Polyfilla
Use as instructed on the packet but make it a bit thicker. Good for dioramas/models/settings also for low relief work. When dry it can be painted, preferably with acrylic type/emulsion paints and/or metallic paints. It can be sandpapered when dry.

Balsa wood
For general purpose wooden (small) models. It is now expensive. Tends to split with the grain. Sharp craft knives will cut thin wood but small saws are needed for thick chunks. Stick with Balsa cement.

Mod-roc
Plaster-impregnated bandage. Cheaper when bought in bulk. It is very good for covering constructions and for creating interesting surfaces. Small pieces of the material dipped in water and smoothed on are easy to handle. Tends to dry the skin, so have some hand cream available.

Expanded polystyrene
Obtainable from packaging, in packs from craft suppliers or bought as ceiling tiles by the hundred from do-it-yourself shops. Fairly cheap. This material can be cut with a sharp knife but is likely to be rough edged.

*Three-dimensional work with
expanded polystyrene*

A hot knife is better, or you can buy battery- or mains-powered cutters
(or splendid table ones). Berol do good versions of the first two. Heated
tools give off heavy fumes – so make sure the cutting is done where there
is good ventilation. Check with your students for allergies or coughs
etc and keep them clear of fumes.

Photography

Cameras

For general use, cameras fall into two main categories – non-reflex and single lens reflex.

In the former group are the *Instamatics. Pocket* Instamatics are not much use, as the size of the film is small and transparencies would need a special projector or to be mounted specially.

All non-reflex cameras have one thing in common and that is, what you see in the viewfinder is not exactly what the lens sees. So if really accurate framing is required, you would need a single lens reflex camera in which, because of angled mirrors inside, you see what the lens is seeing. Both types of camera use 35 mm film, and although Instamatics take a drop-in cartridge and produce square pictures, the actual gauge of the film is the same, so that developing tanks etc will be the same size for both types of film. The Instamatic will do fine for young children to use without more than initial supervision. So perhaps one limited and cheap one, plus a dearer one (which will do more) would serve well for a start. However, for senior work in photography and for recording work, a single lens reflex would be a valuable acquisition.

Since new cameras with various refinements are being produced all the time, it is best to go to a reputable dealer (*never* go to a chemist) and ask for leaflets and advice.

As for price, if you know what you want, then shop around. I have discovered a difference of over £20 on the same camera at different shops in the same district. If the discount shop is well known, then there will be no trouble if the camera goes wrong while under guarantee. *Amateur Photographer* is a weekly publication full of useful advertisements.

If you want some control over what the camera does, so that you can attempt more sophisticated exercises, then be sure to get one with a coupled light meter which will indicate the correct aperture and shutter speed for the light available.

Films These come in different 'speeds', that is, sensitivity to light. Instamatics will tell you what to buy in the instruction book, as these cameras have a sort of common-denominating device for film speeds. Other 35 mm cameras will take any reasonable speed of film – but do ask the dealer to clarify any technical details if you are unsure.

Speed is indicated in both ASA and DIN numbers on the side of the film box and the faster the film, the higher the number. The speed of film you are using will have to be registered on the meter (except Instamatics). Tear details of the film type and speed from the box and tape them to the camera base as a reminder to yourself.

For prints Average fast film for use in dull light conditions without a flash attachment: Ilford HP5 (400 ASA) or Kodak Tri-X (400 ASA). Medium speed for normal conditions: Ilford FP4 (125 ASA) or Kodak Plus X (125 ASA).

For colour transparencies Kodachrome 25 (25 ASA − slow), Kodachrome
64 (64 ASA), Agfa CT18 (50 ASA), Agfa CT21 (100 ASA), Fujichrome
(100 ASA) and Gaf 200 (200 ASA − fast). This latter film has a strong
golden overcast so that pinks become orangy pinks.
Check whether these are 'process paid', you send them back to the
manufacturer who returns them mounted ready to project. Most now
come in plastic mounts but certain firms may still use card ones.
For colour prints The same method of assessing speed is used as for
colour transparencies and there is a similar variety of films. These are
not process paid and have to be developed and printed as with black
and white film. Again, don't go to a chemist as it is unlikely that they
will know anything about photo processing and will not be able to tell
you why your prints may not look right. A photographic shop will tell
you why and if they think the fault lies in the printing they will send
them back without fuss. Always go to the expert for advice.

Developing and printing (black and white)

For methods of developing and printing it is recommended that a specialist
book or books be obtained which take you stage by stage through the
process. The books mentioned in the bibliography are both reliable, clear
and simple. If instructions are followed carefully, developing a film is
easy. Printing is more complicated but if you merely want effective
enlargements, then this can be mastered fairly quickly. If you aim at a
very high standard then this is a different matter. It is still a good idea
to develop your own film even if you have enlargements made
professionally − since it is possible to select the negatives you want
enlarged rather than having them all done. Some shops will provide you
with a sheet of 'contact prints' the same size as the negatives, ask for
this service. Store strips of negative in purpose-made sleeves from a shop.
Equipment for developing film A complete tank for the gauge film you
are using, eg 35 mm. *Durst* make an unbreakable one with a loader for
easy handling, but all reputable makes are good.
2 measuring beakers, 1 photographic thermometer and 2 brown 600 ml
plastic bottles.
Films must be loaded into the tank in complete darkness so beg, borrow
or steal a length of old film to practise with in daylight first − then try
with the eyes closed. It's very simple. Once the tank lid is on firmly, the
rest of the developing can be done in the light. If no blacked-out room
is available at all then a changing bag can be bought (not expensive)
which is also handy if a film gets jammed in the camera and you need
to open the back.
Chemicals These vary for different stages of the work − and of course
your science department may mix them for you. If not, then for
beginners, the following are recommended.
Johnsons' Unitol (developer), *Paterson's Acustop* and *Paterson's Acufix*
(fixative for holding the image once developed).

Developer of this kind is used once only then thrown away (not the whole bottle but the amount poured into the tank!). Instructions come with the bottle and are simple.

Acustop is diluted 1–30 and can be re-used. This lasts a long time. It is yellow to start with and gradually turns to mauve with use – at this point mix a new lot.

Acufix Dilute 1–3 and will keep for some time – the leaflet with the bottle will give you some idea.

The brown plastic bottles are for storing diluted stop and fix. The books mentioned in the list may not mention these exact chemicals as there are so many to choose from, but they will tell you exactly how to go about the process.

Printing and enlarging For this you will need a darkroom however primitive – but with electric points for an enlarger and a safelight. A sink with running water is also an advantage. You will also need three photographic dishes – size according to the size enlargement you wish to make. A base plate or enlarging easel for holding the paper flat beneath the enlarger and possibly (if chemicals affect your hands) 3 plastic forceps. Also needed – a clock or watch with a second hand or a proper photographic timer. The chemicals used are similar to those for developing film except that it is better to have the proper print developer – *Acuprint* is a good one.

From this point the process of printing and enlarging may be learnt from books quite effectively.

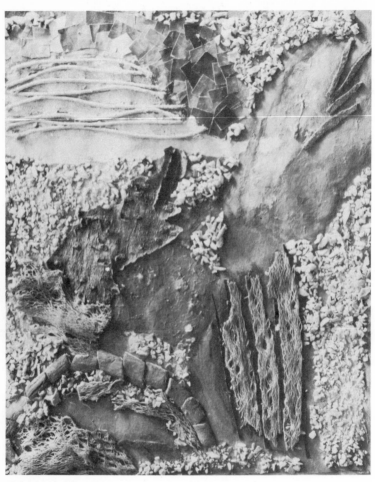

Natural materials

PART 2 BASICS

Colour—texture—pattern and shape—form and light—basic lettering—layout and display

Colour

If we are concerned with colour, then we are not just concerned with paint but with any medium through which colour can be exploited. Here I am assuming that if people know how colour works, then that knowledge can be applied, whether to the use of paints, crayons, fabrics, papers or any other medium.

Whether or not the teacher wishes to paint, it is essential that he/she knows what colour can do in order to provide lessons and opportunities for students to discover variations, effects and relationships of colour in depth.

Primaries Red, yellow, blue (black and white are not colours of the spectrum, they are names given to pigments). The primaries are those colours which cannot be made from any other colours.

Secondaries Mixtures of any two primaries, such as orange, green, purple.

Natural colours are those made from earth, beetles, plants, vegetables, animal matter. They are very subtle, soft colours – ochres, siennas, umbers, dull warm reds, purples and blues.

Aniline colours are made from coal products. These are clear and bright and can be garish if they are not used with restraint and sensitivity.

Saturation This means how pure a colour is as we name it. For example, when any blue is as blue as it can be made. The saturation of colours varies in a scale, yellow saturation may well be halfway along the scale of crimson.

Tints Colour with white added.

Tones Colour with black added.

The colour circle (or wheel) Imagine the colours of a rainbow (the seven colours which make up the visible spectrum) placed in a circle and you have a colour wheel.

Complementary colours Those which are opposite each other on the colour circle. When used in roughly equivalent tones they will create 'vibration', an optical illusion of movement. For example, red and green, orange and purple.

Harmonies Colours with a common denominator or related by their closeness on the colour circle. For example, blue, green and yellow.

Neutrals Greys, off-whites, greys with a minute amount of colour added to give a bias without making a definite colour. A true neutral is a mid-grey which will not have an effect on any pure colour placed on or adjacent to it. The illusion will be that the grey takes on a bias of the complementary colour of the pure colour used. To neutralise a colour add its complementary or grey.

Families A useful name for groups of colours such as blues (all types), reds, purples, yellows and so on. A family stops when the variations come close to becoming part of another family. For example, when in the red family a purple becomes more of a blue-purple then a red-purple.

34

Cold and hot colours are those which are understood most easily, not that they exist as such, but certain colours suggest these states. It is generally assumed that people accept reds, oranges, browns, etc, as hot, and the blue/green family as cold. Beware of the pitfall which arises from the differences between the warm yellow-greens and the cool blue-greens and those equivalents in the red families.

Texture

I divide texture into three types.

Found Actual textures of things.

Imitated Drawings/paintings etc which attempt to convey such actual textures in a fairly accurate way.

Invented Texture suggested by and created by various media used in an inventive way without any textural aim in mind except those inherent in the materials and media themselves.

Most people respond to the more familiar textures, they want to stroke fur and are repelled by the raspiness of sandpaper. Students of all ages should be made aware of the infinite number and varieties of texture

Manufactured texture – rush mat

Natural texture – tree bark

35

Man-made texture — brickwork

and should be made to feel and experience as much as possible — and in doing so to try to analyse their personal reactions to them. After this, a serious effort should be made to try to put down visual impressions, either of the actual textures or of the students' feelings about them. All students should be able to handle a wide variety of media so that combinations can be effective. In the process of this it should be easy to see and to discuss the effects made by mixing the media — and so lead on to invented textures which are almost limitless.

Some textures will be discovered by accident, and accidents can be repeated when required, provided the student is aware of future possibilities.

Collecting things can be a real burden if left to the teacher alone, so try to involve the whole class in a joint collection for the studio. Someone could be asked to separate the collection into types and to keep labelled boxes or cartons for easy access at all times. Classification can be made by the type of texture, whether man-made or natural — and so on. If you have a keen photographer in the group it might be possible to obtain photographs of things which cannot be collected, such as a rough wall! If a couple of cameras are available for school use then it may be possible to take everyone out on a texture-discovering expedition. Displaying textures well can help younger students by making them notice and become familiar with surfaces. Photographs of equal dimensions could be mounted as a 'wall' while fabrics and flat form things can be mounted under categories. Three-dimensional objects can be left standing if there is a surface for them or they could be left in their labelled boxes.

Mixed media

Starting point for invented textures
Greasy crayons Rubbings, layered scraping, water (paint) resist.
Ink on damp paper/on materials (fabrics)/over paint/over greasy
crayons/on blotting or tissue papers.
Torn paper, paste, paint, sand or gravel For sticking down hard stuff use
glue not paste.
Use printing inks inventively and in combinations with other materials,
take prints from inked lace, string, foil and so on – this can produce
exciting results. There are, of course, many variations of these ideas but
do let students experiment freely.

Collage made from prints of textured surfaces

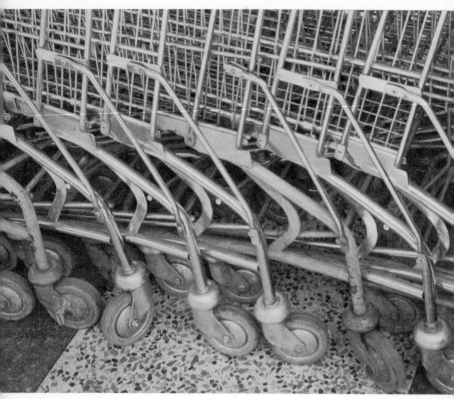

Shopping trolleys — repeated pattern

Pattern

Pattern is an imprecise term and one which does not necessarily imply 'repeating a motif', although it is more readily understood in this context.

When giving a lesson on pattern it is a good idea first to discuss with the class or group its idea and understanding of the term, before making any categoric statement which may later prove confusing. For instance, can the class produce comments on these questions?

When is shape pattern and vice versa?

How would it understand the difference between a repeating pattern and a random pattern?

Is pattern merely decoration, something which is applied to a surface or object to prevent it from being plain?

So, does pattern only apply to such things as wallpaper where a design has been made by an artist — or does it equally apply to a brick wall or pavement where the arrangement of the parts has evolved because of the nature of the material used and the way the parts are put together for effective use?

Is music a pattern? Try recording, visually, a rhythm made by a class. There is no way in which one person can tell another how to lead a discussion and whether or not a conclusion can be drawn, but all teachers should, by their own awareness and ability to clarify ideas, be able to help their students to be equally aware.

As with texture, try starting collections of patterned objects to keep in files or boxes. The students' involvement will help them to see more clearly the differences between types of pattern. They will be able to understand too, where texture and pattern sometimes overlap.

A properly ordered collection, once established as an on-going activity, will stimulate all sorts of design activities for a variety of age groups. According to age and need, these can range from simple repeating patterns made from cut paper or potato prints to much more complicated projects, dealing with colour relationships, spatial problems and shape development.

Here are some categories to consider for collections. Cuttings and photographs can be part of it, as well as materials and objects:

Patterns found in natural things — fish, plants — in manufactured things — windows, stairs.

Patterns invented wallpaper, fabrics, masks.

Manufactured objects pattern evolved through construction: baskets, sisal mats.

Found in structural relationships fences, walls, pavements.

Accidental placing piles of slates, stacked shopping trolleys. Usually repetition.

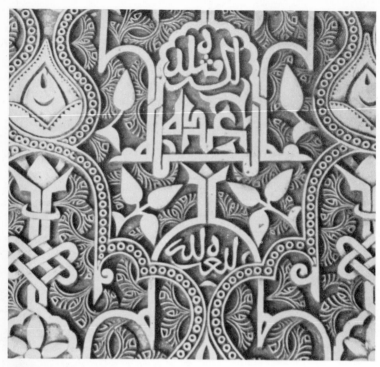

Wall design from Alhambra, Spain

Painted pattern

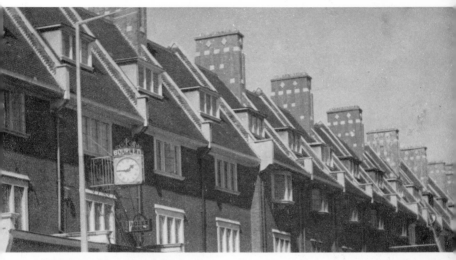

Pattern created by roofs and chimneys
Pattern created by stacking chairs

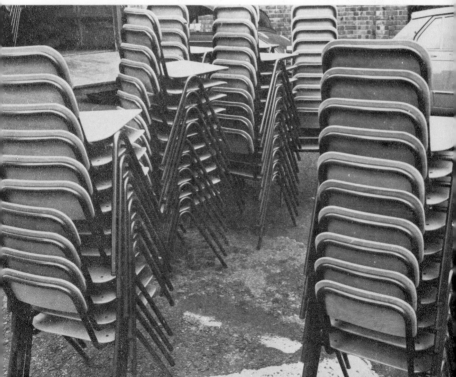

Shape

While most people see that shapes are part of pattern, they find it more difficult to see shape when looking at a landscape or a supermarket. Even a still-life appears primarily as a collection of things against a background. The use of the word 'background' implies a sort of nothingness which lies nebulously behind objects. Instead of which, it is really an area broken into shapes by the things set against it and against each other.

Everything has a shape – that is the point which is defined by the turning away of the form of the object so that we see no more of it. Since a line is so often used to show this turning point, the word 'outline' has been used and this can be misleading.

One of the easiest ways of making students aware of shape is not to allow them to use any tool which makes a line. Cutting directly into sheets of paper will produce shapes which can then be arranged to trap other shapes between them and finally between all of these and the boundaries of the picture area.

Shape of a plant cut from paper

Painted shapes of houses

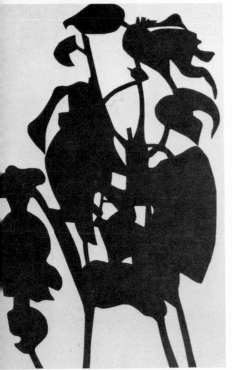
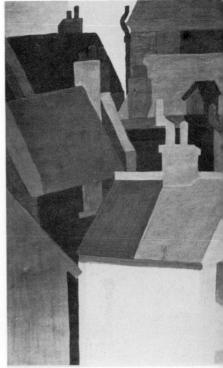

Working this way and sometimes with transparent (or tissue) paper, it is possible to overlap shapes and to produce a great variety of arrangements of the same group of things — whether abstract or figurative. Always encourage students to try a number of arrangements before making a decision on the one to develop — it helps them to make judgements and not to rely on instinct.

Distortion Try fitting a number of shapes into different size and shape of area so that the design has to be adapted without losing the original shapes completely or distorting them out of all recognition.

Overlapping Many students avoid this unless encouraged and will therefore continue to see things in isolation — particularly in a landscape.

Related Shapes which have some common denominator or element will tend to trap shapes which are also likely to relate in some way.

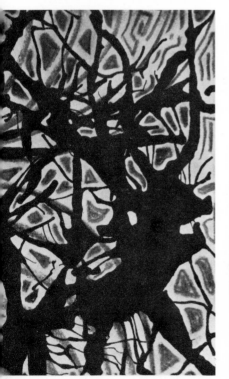
Shapes created by trickled ink

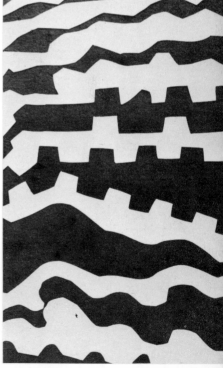
Pattern and shape together, showing positive and negative elements

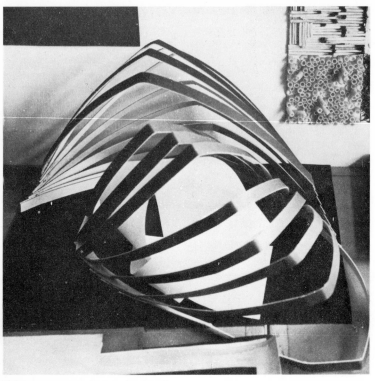

*Paper construction, showing the play of
light and shade*

Form and light

Seeing and appreciating the qualities of form depends basically:

1 On being able to feel it.
2 On being able to walk round it.
3 To see it because of light falling on it. (Even a three-dimensional object may appear flat if it is lit ineffectually.)

To encourage an awareness of form, collect things which are interesting all the way round (natural or man-made) and those which are small enough to hold in the hand. Man-made objects should be chosen for their design qualities or for their surface related to the form.

Place them in different lights and see how, according to the fall of light and shade, different aspects will show, will vary in strength and how some previously unnoticed subtlety will become apparent.

46

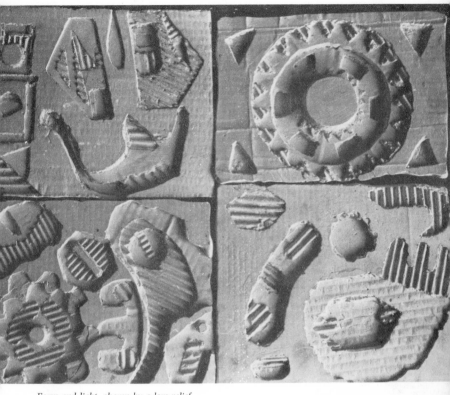

*Form and light, shown by a low relief
plaster cast made from corrugated
paper*

Plain coloured light (use coloured acetate mounted in slide mounts)
projected on to objects on a white surface, will not only change the
colour of the object but will produce shadows in the complementary
colour to the light. For example, red light will give green shadows.
Since a form is defined by the points of change of direction of its
structure, it is a good idea to draw lines on the acetate in any direction
and when these are projected on to the object they will follow or cross
the form. Try it on students faces. If objects are washable, paint lines
on them in stripes. These experiments should give you a start for others.

47

Basic lettering

General advice

It is essential that lettering should be even, clear and uncluttered so as to clarify the message rather than confuse it. The eye should be able to move comfortably along and down the lines, or from message to message if this is not in one block. A good basic alphabet is one based on a square and having strokes of even thickness. This would mean that the O is circular. Learn to make good capitals.

Letters may be divided into four categories.

Those occupying the full square: O Q D C G X Z

Those occupying a half square: E F S B J L R

Those occupying three-quarters of a square: Y V U A K N T H

And those a little over a square: M W

The points of A, M and W are extended slightly above or below the line to counteract the illusion of shrinkage which otherwise occurs.

Guide lines should always be ruled in and if they are lightly drawn, may be left in.

Spacing This has to be done by eye but a helpful rule is:

Two adjacent curves – close together

One curve against one straight – farther apart

Two adjacent straights – farther apart still.

Letter spacing

Left to right: fine felt tip; thick felt tip;
soft pencil; pointed brush; straight-
edged brush

It is easier to learn good capitals well than to try too many different styles, or even to learn lower as well as upper case (ie, small and capital letters).

Do not ignore the possibilities of a good, even script style. Practise enlarged handwriting on a blackboard. Broad felt-tip markers can be useful in this respect too.

If thick/thin letters are wanted, remember that the thick ones are the down strokes, which correspond to the natural pressures of the hand when writing.

Whatever tool is used it should be used according to its own characteristics and the natural movement of the hand.

The basic structure should be retained in the letters but interpreted through the tool, This all applies to fairly functional free lettering, not to the elegant must-be-perfectly-done styles.

Aids for large letters for posters and display

Sources Letraset catalogues (buy at a shop which sells the products). Newspapers, magazines. Tracings from books of lettering.

One basic Letraset alphabet could be bought and each letter put on to acetate and mounted in slide mounts. If these are glassed they cost more but it is worth it to have a set for permanent use. If the letters are projected on to your paper attached to a wall, the image size can be controlled by the distance of the projector to the wall – then the letters can be traced off straight on to the paper. If tracing or greaseproof paper is used, then the traced image can be moved about on the work sheet in order to make sure spacing and arrangement looks good.

Punctuation and numerals follow the proportions of the letters. Space between the lines can be varied according to the length of line and size of letter.

If you are using lower case (small) letters and you wish the lines to be equally spaced – ignore the 'ascenders' and 'descenders' (the tops and tails of b's, h's, p's, y's etc) and concentrate on keeping an equal distance between the 'x-height' of your lines (ie the top and base lines of such letters as x, a, m and s). After all, you cannot guarantee an ascender or descender will occur on each line, so it would be impractical to base your spacing on them.

Ronald Shiner, Dora Bryan, Leo Franklyn, Liz Fraser). 1962. A fast and furious film farce about a man reincarnated as a parrot, with the regulars from the Rix Theatre of Laughter well to the fore. And there are some priceless cameo performances from the supporting cast, including Robertson Hare as a dithering doctor, John Le Mesurier as a long-suffering court clerk, and Kynaston Reeves, hilarious as a deaf ain as a cinema movie in 1971, this drama about a hippie marine attracted attention because of both its theme and the performance of its handsome young leading man, Jan-Michael Vincent, who was quickly snapped up for other star roles. In the supporting cast is Richard Yniguez, who has recently soared in popularity. You may have seen him in the leading role of the recent Sunday evening TV movie,

When the boat was near enough, Harry shouted. In it were a boy and a girl, and they smiled at Harry in a friendly, encouraging way. They came alongside very expertly. "It's all right," said the boy, "we'll soon have you ashore." And he reached up to help Harry climb down.

Their carved, overhanging eaves below tiled roofs throw the narrow streets into deep shadow, which makes it difficult to judge the angle of the sun, and consequently in which direction one may be wandering. Traffic is one-way, and pedestrians dive into doorways to allow it to pass. Though the vaguely Italianate architecture owes a great deal to the Renaissance, in some respects these streets are unlike their counterparts in the northern Mediterranean; there is no washing strung across from one house to another, nor bright splashes of colour, nor much evidence as to the day to day life of the citizens. The

Type samples from a magazine and a children's book. Compare with the text of this book for a sample setting of average adult reading matter. Note the use of different type sizes and lengths of line, according to the sort of publication in question

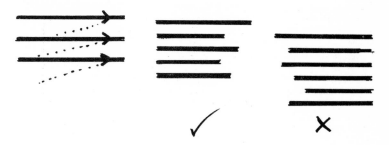

The eye travels along a printed line in the direction of the arrow and returns as indicated by the dotted line. It is often easier to read print aligned on the left rather than the right

Layout for posters/visual aids/mounting

Points to consider The eye, reading English and most other languages, moves from left to right then starts back to begin the next line. It is therefore better to line up the lettering at the left than on the right. There should be no ambiguity concerning the relationship between caption and picture where several are mounted on the same sheet. Clarification can be made with numbering – but this never looks very inviting and there are other effective ways. Don't put titles to pictures if they are not really needed – labelling a picture of a tree 'Tree' is just plain silly, but it is amazing how many people do this.

Avoid tilting Some people think that this is 'artistic' but who wants to have to wave their head from side to side in order to see a picture the right way up? The best arrangements are those which are comfortable to look at and to understand. If possible keep shapes of cut-out pictures rectangular (use a set square for right angles) whenever this is possible. Odd shapes can be difficult to arrange and make the arrangement look muddled. Also few people can cut round subjects without some sort of damage to the image occurring. If cut-outs cannot be avoided they can be mounted first on their own rectangles, then these can be planned into the layout.

When mounting in colour, choose with care – don't let the colour dominate the information. If in doubt choose a neutral. Brilliant colours can be very effective but should be used with care and discrimination. Never use too many entirely different colours in the layout or display, use different versions or tones or choose a colour scheme which suits the subject.

Multi-coloured lettering confuses the eye – children use it because they think it is cheerful but in reality it weakens the message by its confusion. Thin, open letters are weak too, so get the thickness in proportion to the size.

*Keep the arrangement of captions and
pictures simple and unambiguous*

*Mount irregular shapes on rectangles
of their own before composing a display*

Alternatives to presenting material on flat sheets

A folder for display

Folder Pictures should be on one side only if sheets have to be stuck or tied.

Pockets In order to construct a pocket, look at pocket files sold in stationers and either use them as patterns or use one directly, stuck onto card with appropriate titles or instructions. Cut the flap away if pictures or sheets are to be held which are tall or need to be removed freely.

A pocket display made from a
manufactured card wallet

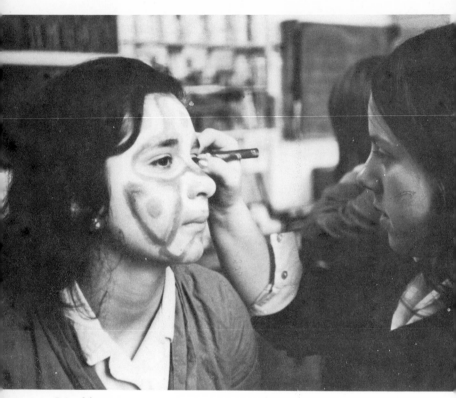

Painted faces

PART 3 ORGANISATION

The room—materials—the lesson

The room

Every experienced art teacher has his or her own ideas on studio organisation and since no two studios are alike or equipment uniform, this chapter will offer points for consideration and general advice rather than a firm solution to problems.

Most of us are faced with rooms for 'Art' – that is, rooms with art furniture in them, or a purpose-built studio which has been adapted over the years by a succession of teachers. There will certainly be little or no money for radical alterations. It is assumed here that specialist studios for pottery, woodwork etc are adequately equipped within their prescribed activities but that a general-purpose art room can present difficulties.

All activities likely to take place should be analysed for practical purposes. For instance, a gas ring for boiling dye may be some distance from a sink, so carrying a bowl of water to the gas may be hazardous. The line for hanging wet cloths should be near the sink otherwise a stream of students carrying dripping cloth can be messy and dangerous if the floor is the type which becomes slippery when wet.

Where possible, furniture should be easily movable so that floor areas or wall areas may be freed for working or for display surfaces.

A variety of types of furniture is often more useful than the more impressive-looking, uniform sort, since there can be a greater choice of flat or upright surfaces. Whatever the equipment available, always make sure that there are gangways or spaces for students and teacher to move around freely.

The way students are allowed to enter is very important. Some teachers assign places – which works as long as the furniture isn't moved. Allowing students to choose their own seat is more satisfactory provided that it is made clear that they will not be allowed to stay there if they don't work or if there is any argument. This also gets students used to the idea of change so that they aren't flummoxed if they are ever confronted with an unexpected situation or arrangement. Never let a class or group rampage into the room for any reason. A bit of old-fashioned discipline at the beginning can save all sorts of hazards.

If students bring bags into the room, make sure they are stacked out of the way. Before learning this lesson, I knocked over two children, an easel and several pots and palettes when I fell over a bag left in a walking space.

Accidents are rare, but should they occur they must be dealt with swiftly and with determined calm. A class must be calmed at the same time that an injured student is dealt with, in a manner which can be seen to be effective. Firm and clear orders will give confidence and restore order. Teacher fright must never be visible – do your own shaking afterwards. Some mishaps can be hilarious and it is best to let everyone have a good laugh to get it out of the system. Remember that boys

giggle just as much as girls.

Cleanliness for students is important and they should be encouraged to wear overalls. The familiar cry of 'I've forgotten it' should not be viewed with sympathy. To prevent embarrassment for less well-off students it can be made clear that any sort of covering will do – old shirts, pyjama tops, etc. These are all more effective than front-only aprons. There should always be a good supply of newspaper for covering surfaces when using messy materials. Students are notoriously lazy when it comes to clearing up, so some method should be devised whereby certain people each week are responsible for cleaning equipment and replacing it. It is up to the teacher to decide whether to have a rotating system or a semi-permanent one – this depends very much on the age, character and size of the group. Sometimes students themselves can come up with a better system than the one already in operation. Every teacher will have to review his small world and work out, quite clearly, a satisfactory method.

Newspaper for printmaking sessions is absolutely essential. Waste paint can be scraped off palettes with a knife and everything then wiped clean with damp newspaper (for water bound inks – turps substitute must be used for oil-bound kinds). Rollers can be run over the paper (one way only otherwise the paper winds round) till only a thin film of ink is left for cleaning off. Inky remains can be wrapped in clean paper – otherwise the cleaners may well complain when they empty sticky bins.

It is well never to allow a group to leave the room until everything has been checked and the furniture seen to be clean. This sort of orderly end to a lesson will also help to prevent a great explosive exit from the room. If students are allowed to go out individually, then their places should each be checked first. This advice may seem restricting, but many new teachers have found themselves frantically cleaning up messy rooms just before another group enters or in the tea break. Mislaid equipment can be a nuisance as well as expensive. A good system, once established, becomes a good habit and in the end takes a great deal of worry out of this aspect of the job. If you wish to change the existing system, always make sure the new one is understood and see that instructions are repeated for a few weeks to break the old habit. 'One-off' methods for special or non-routine lessons should be done in stages if possible as students have bad memories (or sloppy listening habits) where instructions concerning work are concerned.

Where there are supplies or tools used for each lesson, they should have their permanent homes so that they can be returned easily without students asking 'Where shall I put this?' each time. Even with established sites, this question will be asked with infuriating regularity, but at least the need to ask will have been removed.

Pots for brushes, sponges for cleaning tables, boxes containing drawing

pins or clips, should be readily available. Tools of any sort will presumably be shut away in drawers and cupboards and should not create the same problems.

If possible, buy or make racks or holders for tools which have to be counted in — such as scissors or pencils — so that a gap or empty hole will show up immediately. Cheap photographic trays are useful for keeping things in, as are cat litter trays if they are not too expensive.

Materials

Where possible, organise materials for a class before it arrives and have them grouped or put out in some ordered way for convenience. For instance, paper in one pile gives rise to scrambling — so place several smaller piles in different parts of the room or on separate tables. It's a complete mystery why students always scramble for supplies even when there are plenty — and how each individual is reluctant to take the top sheet however clean it is. Convenient places should apply to all equipment — perhaps a table set aside — this of course is for a room without purpose-built storage.

Materials in short supply, or so expensive as to be a luxury, should be given out carefully by the teacher and an explanation given for this. It will mean that every student has a fair share and no-one will have cause to grumble. If the goodies are not identical, swopping may be requested. This can cause noise and argument so it should be made clear that the owner may not be bullied to give up his prize if he is content with it. Scraps, newspaper and junk etc, are best kept in large, strong cartons so that they can be accessible at any time, and things like glue, scissors, knives should be kept within sight of the teacher.

Machines

Setting up any sort of project — ciné, loops, slides — may seem simple but it can produce problems. First of all, never forget to book the machine well in advance and the room too, if you need it. If, however, the machine is studio-based (or has been made available) there are other things to consider. Where are the electric plugs? Are they on the wrong side of the room? Are some of the students to be working while others use the machine?

Always establish the machine in a suitable place before the class arrives and do make sure the slides are the right way up for projecting.

Note Paint a red spot in the bottom left hand corner of the slide when held in the hand the way it should be seen — then the slide is placed so that the red spots can be seen in the top right corner by the projectionist.

Minimal blackout works if the projector can be placed near the screen or wall — which means a small picture but may be suitable if the audience is also small. This also works conveniently if the group only

wish to use the machine intermittently. Long stretches of flex should be clear of furniture and students warned of its position as they enter the room.

It is possible to put a machine into place during a lesson, **providing** the teacher is clear where it will go and that students can move without too much disruption.

It is a good idea to encourage students to be able to use the simpler machines themselves — and so leave the teacher free. The whole group should be instructed at one time — clearly and logically — and then their understanding checked. For instance, they are unlikely to know that, even with an air cooling system, slides are likely to be damaged if the projector is left on for any length of time. They must always switch off when they have finished.

Warning Don't think because a group understands all this that they will not forget it sometimes — so whatever you are doing, keep an eye on the machine.

Where cameras are concerned, a detailed and clear lesson on the working mechanism should be given and work cards (this could be done by the students as a lesson in design) made and kept for future reference. If used at infrequent intervals, people forget how things work. Students should always be encouraged to understand the tools they use — the sort of film to be used and how it works in relationship with light, how to put it in and take it out of the camera. Try to make your students less helpless about such things. Take care not to lose the instruction book which comes with any sort of machine.

Where machines are used by many different people, they are likely to break down more often than one expects. If they do so in the middle of a lesson, organise an alternative lesson/activity as quickly as possible — and calmly. It is a good idea always to have an idea tucked up your sleeve to fill this sort of emergency — prepare it when you prepare the actual lesson.

Glues

Instruction in the use of glue is as important as it is with machines. Glues and pastes vary so much in their use and methods of application that the majority of school students are merely confused and ask for glue when they mean paste etc. Nor do they understand that glues are stronger than pastes and should be used more sparingly — they wonder why things don't stick when they've used glue thickly and it takes ages to dry. Lavish use of any adhesive is likely to cockle paper and damage or stain work — give a demonstration of the use of all adhesives available and repeat this each year or when bad habits begin to form.

Keeping wire tidy

Wires and pliers

Anyone who has not been instructed in the use of wire and pliers quite possibly has experienced the terrible muddle of wire coils pulled from both ends, and will have been presented with twisted and distorted wire where students have not realised that cutting pliers have the cutting part near the handles.

It is tedious to have to feed wire backwards through the containing twist – but it is preferable to the muddle.

Briefing – the lesson

The duration of a briefing depends on the lesson itself and the sort of students who will be listening. It can last for two or three minutes or over half an hour. Sometimes the briefing can take the whole lessons – but this, of course, would include discussion and planning with the group, the collecting of ideas from everyone and perhaps, the demonstration of a new tool.

In fact this sort of briefing *is* the lesson, so that the following week (or whenever) the briefing would be very short indeed. Knowing the content of a long briefing and planning it logically, so that talk, action and discussion are timed to keep interest at top pitch, takes a great deal of working out but can be enjoyable if the class becomes involved. It can also help the students to plan intelligently.

Apart from very short briefings, it is well to re-cap on the main points before the class begins work and make sure that they understand your terms. Just asking if they understand does not serve any good purpose – very often they *believe* they understand – so that it is not until things go wrong that misapprehensions are revealed. Ask questions after a quick re-cap.

If you forget something, don't worry – just recall the attention of the group and go over the missed point. I once heard a student teacher give

a good lesson on houses, but noticed that there was no discussion or mention of chimney pots. Thirty paintings of houses without chimney pots was the result! When I told her why, she recalled the class and asked them to look out of the window and to note any big difference between their paintings and the houses they could see. It was obvious at once and the paintings became more interesting. Anything, in fact, which crops up after the initial briefing can be dealt with in this way. It can be a blessing sometimes — re-kindling flagging interest or just calling attention to the need for thought and observation.

There are two schools of thought concerning the relationship between talk and activity. Is it best for students to collect their basic materials first and so be ready to listen and to begin work immediately afterwards or it is better to listen first and then collect the most appropriate tools? Some people think a sort of half-and-half measure is better. This one point shows how necessary it is to plan lessons well ahead and to make decisions in the light of requirements and convenience.

Having decided the order of talk and activity, make sure that furniture is arranged accordingly. It is not always necessary to move all the furniture yourself but make sure your instructions to the students are clear — once they start to move, your voice will be inaudible.

If a projector is to be used, the seating must be organised for unobstructed viewing. If pictures/books are to be held up, then the seating/standing pattern will be different. Remember that young students fidget if they have to stand for long, so, unless standing is essential, make sure that everyone is seated in such a manner that you can see if anyone is not paying attention.

If visual aids are to be shown only to a section of the class, then the lesson should be given to the whole group first. Afterwards, those needing the visual aids may stay or move to a designated area while the first section gets on with its work.

Sometimes the whole class may sit in its working places while you talk, but make sure that each individual can see and be seen or you will lose some of the attention which might be better held if you were to gather the group closer. Deciding on these practical aspects depends entirely on the aim/content/type of lesson and on the students, but great care should be taken to see that everything runs smoothly.

Where classes are to be split into groups, see that they are brought together first and discuss the project as a whole so that the overall idea is clear to all. Splitting the class is then simple, especially if it depends on the use of different media. If the split is to be made by having various activities, then the problem of dividing yourself into two or three begins! Don't be over ambitious. Try to work out, whether one group, after a joint briefing, could be sent away to plan and decide/make notes, etc for a piece of three-dimensional work while you help a two-dimensional group to start. Once everything is ticking over, it is simple to move from group to group. Within the two/three-dimensional combination, further

divisions can be made via media, without causing chaos. In divided lessons, have all materials available so that you are not constantly interrupted by students asking for things. Use the potential leader ability of students as much as possible. A 'foreman' can be appointed by a group to consider all suggestions and to make a final decision, which can then be carried out, or brought to you for confirmation or further discussion. This can work well and gives students the confidence to make their own decisions within the framework of the lesson and with your expert backing.

Continuing to use leaders of groups during clearing-up time can be salutary – so many have no idea what a mess can be left if there is no proper supervision. If they see it for themselves it can have most effective results.

Lessons

Aims need not be intellectual or complicated, but clarity of thought and direction is necessary. Discard all irrelevant matter, otherwise students will become unnecessarily confused. Ask yourself: Why are you giving this lesson?

How do you hope the students will benefit?

Are you giving them a specific task which will have a conclusion (like a finished picture)?

Are you asking them to experiment: For fun only?

In order to experience something new?

In order to develop something from an earlier stage?

In order to let them draw individual conclusions?

To give them new or further experience in the use of materials or tools?

To make them observe?

To make them comment?

If a picture, is the subject to be chosen by the student?

If so, do you help them prepare/choose?

Do you help them to make preliminary notes/drawings?

Do you give them a chance to observe or get reference material; to experiment with techniques which may be particularly effective for the job?

If the subject is chosen by you: Will they have a chance to relate to it personally?

Will they have a chance to treat it in their own way? – This in addition to the problem you have set them to solve or express.

If the subject is a means of teaching a basic, eg, texture, can you give them guidance on other aspects of the subject/picture without confusing the issue?

Whoever chooses the subject, is there a chance to use initiative and imagination?

Have they too much choice or too little?

If the subject is entirely fantasy, can you help them relate the content to their own inner experience rather than produce clichés?

Special instructions/open-ended briefings

Open-ended briefings encourage independence and initiative by allowing freedom of choice. This may be through a set subject with a wide choice of approach/media/techniques. Or it could be the other way round – set materials with discussion concerning a variety of possibilities of subject matter to relate to and suit, not only the tools, but the personality of the student. A challenging lesson can be made by the group doing a joint experiment, say, with objects moving in water in a bowl. If several experiments are set up, groups could opt to do joint work, or disperse and express individual ideas based on what has been seen. This may end as pattern, texture, analysis of movement (older students), a mobile or a picture based on an idea sparked off by the experiments.

Short or emergency lessons

New or inexperienced teachers would find life easier if they were to have a list of 5–10 minute lessons ready to be used if the class clears up more quickly than expected. And for the times when a group needs to be occupied for a short period when there is no equipment available. There are many ways of doing this and starters are given here. Ideas should be suited or adapted to age – and have some 'universal' ones.

Art books available? Show the group a picture and discuss it or the artist – or tell them something about it.

Photographs available? Again, discuss or talk about some aspect, eg, shadows/composition, etc.

Newspapers/comics? Talking point on communication – how effective are the advertisements? What is the relationship between picture and text? Discuss or inform on layout. In comics/strip stories talk about the sort of visual shorthand used by the artist to tell a story in a limited number of pictures.

If there is a blackboard or if a sheet of paper can be put on a wall, ask a student to begin a drawing of, say, a tree and ask other students to alter and improve so that the whole group becomes involved in making the best possible drawing of a tree. It also helps them to become critical in an objective way. The subject could be a fun one or a memory one, based on a verbal description.

Have discussions on any visual object How does a sunset affect a landscape? How would you show that one person is farther away than another?

If there is enough room on the floor or the wall, let students display all their lesson work and let them make constructive comments. Why is this one more exciting/effective than another? Avoid letting the 'worst' piece suffer in a negative way. If someone says 'that's no good' ask them the reason for saying this and try to build encouragingly on the comment. If you start the group constructively, they will follow your lead.

If there is nothing available, then look out of the window at colours/shapes or anything in order to encourage intelligent observation.

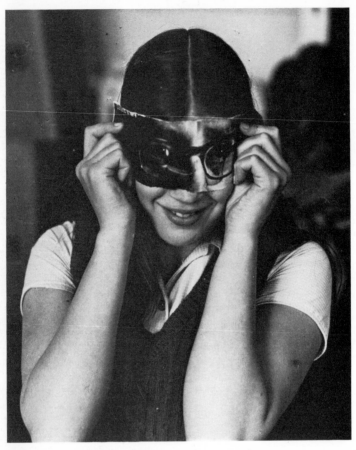

*Girl with magazine cutting — the start
of an idea*

One incident which happened to me may give some idea of how an 'accident' may be used. A class was cutting up magazines for a collage when a girl called to me. She had found an advertisement showing a life-size pair of spectacles complete with eyes and had cut out the whole strip from the page. She was holding it against her face so that older and more sophisticated eyes stared out from a 13 year old face. Her appearance was totally changed and led to a discussion on this. Later the class made masks or half-masks. Funnily enough, the girl who sparked us off made a complete helmet so that the idea was lost in this total covering. Never expect things to work out exactly as you intend! Other lessons could stem from this idea — war-paint, body paint, make-up, fashion in faces — all sorts of things.

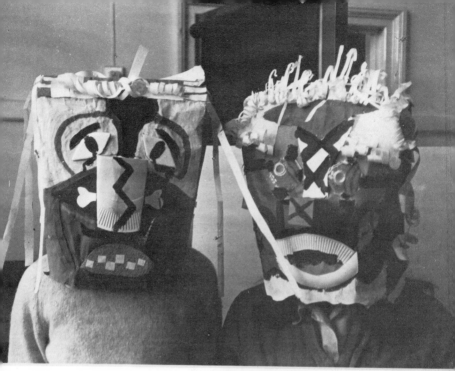

Masks made by the students

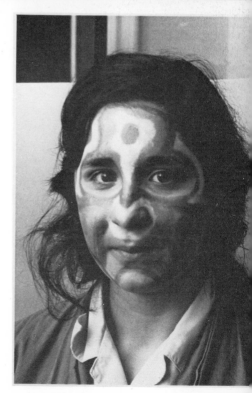

Face painting

65

A painted body shape, first drawn round a student lying on the floor

When to instruct, when to leave alone

Some teachers favour the never-sit-down, go-round-all-the-time technique because they think that students will feel neglected otherwise. On the other hand – and my students have offered this theory – they may feel 'watched' and it will irritate them and put them off their work. An unstable group does have to be watched but it need not be obvious and going round can be discreet.

In the end, the choice has to be made according to the need and type of student, but most people find that, if the briefing has gone well, then students can get on without help for some time – as long as you are available if they need you. It is not a bad idea for students to realise that teachers have other things to do beside teach. When it comes to a 'craft' lesson, then more attention is usually needed – but on the whole, students should be given the opportunity to work on their own and to develop their initiative. The important thing is that, whether a teacher goes round a lot or not, there must never be the feeling that he/she is not interested.

There is also a difference between the quick all-round look and the individual approach. Once work has begun, it is as well to go round the whole group to see that there are no gaps caused by insufficient briefing. If there are, then this is the time to draw attention to the fact. After that, individual attention should be given.

Criticism

Under this heading, too, there are a number of varying opinions – since criticism may discourage students and make them feel inadequate. Most students, however, get very fed-up with teachers whose constant approach is 'that's very nice, dear'. Never give criticism which leaves no room for improvement, either at the time or later on – or gives no hope for the future. Joint criticisms will help to establish your attitude and if it is made plain that the criticisms you make are for improvement, then students will be encouraged to ask your opinion and will have faith in what you say. It also means that when you do praise, then that praise will be appreciated. One way of dealing with a weak part of the work is to approach from the good points and show how these are better – and wouldn't it be good if the rest were to be improved to that standard?

Of course, help in the improvement has to be given too, so that the whole process becomes an on-going thing. Even the most awful piece of work can be helped this way, the end product may still be awful, but if it has improved even slightly, you have something to work on next time.

Atmosphere

A room devoted to the visual arts should be interesting and alive. It should be a combination of functional workroom and a colourful, exciting place to be, with lots of visual stimulus. If there are plan chests in recesses or if there are other top surfaces, these could be used for changing displays of three-dimensional work or objects of interest. Walls could support back-up drawings, etc as well as the usual exhibition of class work. Reproductions of paintings could be used to back a project and ordinary magazine pictures can be exciting and will help students relate them to their work. If you collect wisely then you are likely to end up with groups of things — such as people, landscape, transport — and if the colour in these pictures is biased for the sake of sales appeal, it will make a talking point about 'natural' colour. The possibilities are endless and it depends on the sensitivity and responsiveness of the teacher to see and to use these possibilities.

Mounting and changing pictures can be a real chore, but if you are strong minded about this then you will find that it reaps its own rewards.

PART 4
IDEAS AND LESSONS

Introduction: the syllabus—Sources of ideas—Starting from materials: mixed media—Line, drawing and tone—Painting: freedom and control—Textiles—Natural objects: landscape, townscape—Man-made objects—Still-life—Fantasy and imagination—Open-ended briefings—Music, sound and movement—People: life drawing—Scale, proportion and distance—Conclusion

Introduction

Many teachers regard a syllabus as restrictive and not conducive to freedom and expansion. But if used intelligently it can form a valuable basis on which to work, and a jumping-off point from which to expand. It also presents an order within which to grade lessons according to age groups in such a way that, however varied, the work of one year can be built upon in the next. Public examinations are then taken as a logical end to a course and do not become a traumatic experience. Sometimes it is difficult to believe that students have learned anything in the previous years – but if they continue to study art all the way through the school, good teaching will ultimately make its mark. Even if examinations are not taken, a basic syllabus can be used, adjusted and will be invaluable in times of staff sickness, for student teachers and for new or temporary teachers who have to take over. If a lesson book is kept too, with records for each class, then at any given moment a newcomer will be able to see at a glance what has been done and what remains to be covered during the year at any age level.

At the other end of the scale, if the syllabus is too detailed and specific it will become a nonsense in the face of changes of staff, timetable changes, student temperament and changing ideas. Accept it as an ordered but open approach to continuity and re-appraise it each year. Some groups can tackle certain problems at a certain stage while another group will perhaps take longer to arrive. This pattern changes from year to year so too, must the syllabus.

Sources of ideas

Student and inexperienced teachers often have a real neurosis about getting ideas – they say they have none. This is rarely true, it usually means that they have not learned how to look, how to analyse what they see and how to make use of it. In fact they are very much in the same position as their students in this respect. They will, however, learn quickly how to use all their senses and build on their adult intelligence and awareness. This difficulty, of not realising possibilities, also applies to any experience whether tactile or theoretical.

People see their environment on the way to work but cannot sort out what they see, there is too much of it. They are attracted by a picture, in a magazine, for example, but don't know how to use it. The first thing to do is to put one's mind in order and just jot down anything which attracts in any way at all. Keep a small notebook in your pocket or handbag, don't rely on memory. Divide the jottings into pages containing related ideas and add to them gradually. Ideas will soon begin to emerge.
Example Under 'Buildings' you might have something like this:
Alleyways – looking through old fences – recession – lines of fences – holes – rubbish.

*Different emphases of tone which could
be developed into semi-abstract work*

Windows: Seeing through – reflections – reflections in the one-way
copper sort – repetition of oblongs – window boxes – window cleaners –
change of colour (curtains) in tower blocks – curtains blowing out.
Already you can see that there are ideas emerging for use in terms of
colour, pattern, shape – and pictures. Think of Stanley Spencer's
painting of the Crucifixion in the Tate Gallery and how he used window
cleaners and blowing curtains. If you have a reproduction it could be the
starting point of a discussion on how other artists have used elements of
their everyday surroundings.

Other ideas

'What a beautiful tree' Why? — Autumn gold against a smokey sky —
spaces between — Rough greeny-grey trunk — Colour, shape, texture,
viewpoints (looking up into the foliage), landscape, distance (add more
trees). Are things always the colour we think they are? Many people
people think that tree trunks are just brown.

The milk was bad, it tasted horrible Bad milk — milk — liquid — bad
liquid — scum — scum on water — ponds — reeds — frogs — tadpoles —
children plus jam jars and so on. Many ideas here. Or you might take a
different direction: Bad milk — bad — rotting — destruction — corrosion —
rust — mould — metamorphosis — worms — eating away — texture — Also
— bad taste — bitter — grimace — teeth — frown — portraits — expressions.
Your original ideas may never be used, but if they produce a lesson or
series of lessons it is immaterial where the first ideas came from.

Television provides endless sources of ideas. A thriller could start you off
investigating cars and movement, the effect of fear on the human face,
in fact all sorts of things. Anything is useful, even if it is stored away in
your notebook for ages. Don't try to work in a vacuum.

If you think it's time that your students worked on the problem of form,
then your notebook might have something in it: eggs in a supermarket —
women with baskets holding packages — feeling the solidity — fruit —
endless ideas which can be investigated or serve as a start to a painting
or a piece of three-dimensional work.

If possible, take your groups for walks, even if you work in what is
considered to be a visually deprived area. It isn't, of course, as there are
things to be seen everywhere although they might not seem attractive.
Allow your students to make notes and do quick reminder diagrams.
Take rubbings if loose sheets of paper are available. Even with a simple
camera, let each student take a photograph and be prepared afterwards
to say why it was taken. Encourage them to look at various distances,
far, medium and close-up, or give them a theme to work on so that all
their notes for that walk will be directed to some specific discovery
rather than a hotch-potch of unrelated things. When you get back,
someone might want to write a story or poem. Never discourage anyone.
After all, this might lead to a series of lessons on book illustration or
making booklets — with all the attendant techniques. Don't think that the
walk hasn't produced 'art' — it will have increased awareness and the
ability to observe and select. The subject is not separate from life, it is a
part of it, or should be, and the expression 'education through art' is no
nonsense. Writing is as valid a means of expression. Art and writing go
together with sound to make complete communication.

Ideas may come from reading and from listening — and if you have a
tape recorder to take on your walk this will give you even greater scope.
Noises as well as speech can be recorded in relation to the things seen
and noted. Sounds by themselves can spark off ideas — grating sounds
may well be associated with textures or a voice may suggest a character

for a portrait.

A piece of screwed up paper may give you the idea of doing this deliberately to a large piece of paper for students to experiment with the effects of light and shade falling on the facets. A piece of broken glass could start a series of lessons on the subject of change – changes in an object brought about by distortion, breakage or any other means.

The use of different media in this type of work will broaden experience. After a series of experiments try to allow for some development which might be referred to as a conclusion (usually a finished piece of work of some kind). Very few things are finished or concluded in the sense that there is nothing more to be done at any time, but there are pausing points in all learning, where a temporary stop has to be made.

Use of reference

The use of books, pictures, films or slides for visual information gives rise to a great deal of discussion among student teachers. Some feel that it is permissible to copy a picture when actual material is not available, others, like me, believe that this does not do anything to advance the students' knowledge – only the superficial image.

In a lesson designed to encourage the imaginative use of colour and texture, I once gave a bird as the subject. It may seem unlikely but few young students know what a bird is really like – how its head joins the body, which way the legs bend. To increase their knowledge I showed them a restricted number of photographs and discussed the structure with the class in detail. The books were then put away so that the students (11 years old) could invent their own bird but with some knowledge of its structure.

A student teacher asked me, since the paintings of the birds would have been much better if actually copied, why I had not let this happen.

The answer is very clear. When inexperienced people of any age copy, they use only their eyes and their hands so that the image, once copied, has little or no place in their visual memory. An image which has to be remembered afterwards is looked at more carefully in the first instance and the act of trying to recall the structure trains the mind for other occasions when more knowledge or information is given. Learning is a cumulative process.

It must be remembered that the word 'student' covers an age range from 11 to 19, so that the youngest are children in experience as well as designation, and they have a limited, if varied, ability for visual and aural retention.

Knowledge and information is best fed to them gradually and as lessons are graded, so should be information, which is then built up gradually but steadily. This is why lessons should be prepared carefully.

Bird, created after controlled access to
reference material

Landscape technique using a magazine cutting

Old masters sometimes copied techniques of other artists, but they were skilled adults, clear in their minds as to what they copied and why. Remember too, that this was before the invention of the photograph. This cannot be a valid argument for allowing school students to produce a work which they think is good because it is a good copy of someone else's work or of a photograph. A photographer has already selected an area or subject and turned it into a two-dimensional piece of work – so that by copying, students would not even begin to learn to select and to translate for themselves.

Other artists' drawings are not always good or the information in them accurate, but the use of slides, photographs, films, books, and film loops is perfectly valid if used to provide information on:

1 An aspect of a familiar subject which is not available 'live' at the time, eg sunsets, thunderstorms or general landscape. They serve as reminders of what has been seen before, and will give different emphases (colour in weather) and add further knowledge.

75

*Work sheet reference and the finished
article*

2 On specific things unlikely to be available in reality, eg wild animals,
tropical flowers or plants, aeroplanes and ships. Have references which
show several viewpoints rather than just one, so that a general feel can
be worked out. Details are important — paws, wheels, funnels etc.

3 Subjects always in motion so that we normally only retain the visual
impression of movement. Loops are good for this sort of subject. In using
slides or loops, it is a good idea, after the first good look and briefing, for
the students to be allowed (if trained in using the machine properly) to
refer back to various pictures or sequences during the lesson, providing
that no-one sits down for a good ten minute look!

Figure, painted after use of reference

There are other occasions for using references which must follow the individual need. Always try to get sufficient reference so that students select what they need most and try to remember the rest. This will ensure that there will be plenty of themselves in their work and the whole group will not produce almost identical results.

Starting from materials: mixed media

It is usual to begin a lesson by giving a briefing on a specific subject, so occasionally, it is refreshing to start with different materials. Separate surfaces can be used for students to move around. Try a 'feely' table — objects and pieces of anything suitable underneath a cloth so that they can be felt but not seen; a 'look' table and a 'pick-up-and-feel' table; there should also be a 'use-it' and equipment table. The latter could hold not only conventional tools but unlikely things, such as twigs and pieces of foam rubber; these can be used with inks, dyes and paints. Students should be encouraged to feel and to express what they experience in any way which comes to mind. For instance, if the material is scratchy, try to paint or use other media to express 'scratchiness'. They should also be encouraged to use as many different tools and combinations of tools as possible.

If the results of the experiments are kept small, they could all be trimmed and mounted so that the whole group could review its joint efforts and discuss possible developments; either in terms of more experiments taking a different direction or in trying to use them for some specific purpose.

One thing to remember is that a lesson like this should be followed by one which opens up a variety of possibilities for applying and extending new ideas, otherwise students will see this merely as a sort of game for its own sake.

Whatever the subjects given as follow-up, they should be fully discussed, so that students will see variations of interpretation in terms of materials suited to the subject. If some of the materials set out suggest three-dimensional constructions, then they should be backed by suitable tools. For instance, a heap of polystyrene pieces should be backed by the appropriate glue and some sort of cutter — plus adequate ventilation. This is a lesson where you, the teacher, will be much in demand, especially at the beginning, so make sure that everything is to hand and you are therefore free, not only to discuss with groups who have not made up their minds but with individual students, who are sorting out how to achieve the best results.

In reverse, if students are to be expected to mix different media successfully, they should first become familiar with what each medium can do separately and then be given the opportunity to put them together simply as materials. Techniques and ideas do not necessarily keep pace but a teacher should be able to keep things as level as possible.

Collage of magazine cuttings and ink work

Owl, collage made from sheets of rubbings

Fish and chips, collage of paint, paper, polystyrene and other materials

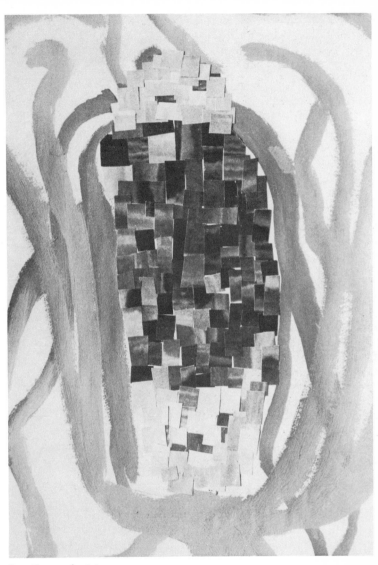

Corn. Paper and paint

Line, drawing and tone

Line

While it is necessary to talk about line to students, the word *outline* should be used with caution. A line encloses a shape or defines it and becomes a graphic device for expressing the outer limits of a form, where it is the only way to show a division between, say, white paper and white paper. If shading (tone) is used in a drawing then there is no need for a line at all. Without thinking about the term 'drawing', there are many different types of line, many tools which will make them and many ways of using line. In fact, to experiment with marks and lines with any graphic (drawing) tool will help give confidence in the use of those tools and therefore leave the student more free to concentrate on what he is drawing.

Given a range of mark-making tools, ranging from fingers to twigs, as well as the more conventional ones, it is possible to make an enormous variety of lines and spontaneous marks.

Lines can be delicate, strong, nervous, decorative, heavy, straight, coarse and so on. Marks are equally varied. Discussing lines and marks can be fruitful before making experiments.

Line

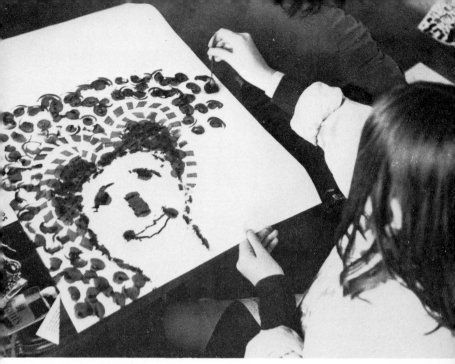

Ink drawing with improvised tools

Landscape from life

Drawing

The putting together of marks of all kinds to make an ordered whole which may end as a recognisable object or may be merely satisfying to look at.

When students lack confidence in their ability to draw, it is usually because they are old enough to have become conditioned to the adult idea of what makes a 'good drawing', and do not feel that they are able to achieve this. It is essential to break down the conventional concept of drawing – which is pretty, neat and tidy and, moreover, recognisable as something – such as 'a boat', 'a mountain landscape' and so on.

Drawings which are direct and in which the thinking and looking are evident, are much more vital than the self-conscious 'look-how-well-I-can-draw' pictures which so many people admire. Such people not only expect to recognise the subject but to be able to do so within their own limited visual experience. But there are many ways of looking at and interpreting things, and the artist should be the one to decide what and how he draws.

Try to present drawing as an exploration and a way of explaining the appearance of something, or of some aspect of it, without the use of words. Make the students look so hard that they forget their tools and draw unselfconsciously. Make them understand that a good drawing is not necessarily 'pretty' but should communicate an *idea* of some sort, whether realistic or abstract.

Pen and ink

Experimental line work

Cat, pencil drawing

Once students begin to enjoy their drawing, their horizons can be widened, perhaps, by drawing three different views of the same thing, or using three different types of media such as pencil, chalk, ink. Try to give them as wide a variety in their choice of tools as possible so that they become selective.

If the drawings are to be used afterwards as reference for some other piece of work, then this too will help to direct the attention towards recording as much information as possible and 'prettiness' will not arise, although drawings should not appear to be servant to other things all the time – otherwise they will always end up as purely functional. Somewhere along the line a balance has to be made so that ultimately, drawing will be a natural and on-going activity, whether as a means of information or as a subject in its own right.

*Section through an artichoke, pencil
drawing*

To most students, looking is often a quick glance, and therefore
uninformative. So make them hold an object and feel it, peer at it, turn
it over, ask 'what's that bit?'. Ask them to show what they see to you
or their neighbour – and you can point out to them the things they
haven't mentioned or noticed. Make sure that every part of that object
has been experienced before drawing begins.

Sketching is a word best not used since to students this usually means a
quick look, a quick line – and as such is without value. Sketching, for
the expert, is a form of note taking, a visual shorthand, backed by a
trained visual memory for what is left out. This works only when the
artist's quick look takes in as much as the beginner's long one and/or
when the ability has been acquired to select the salient points of a
subject.

2B pencil

Very soft black pastel

Thick graphite stick

Greasy crayon

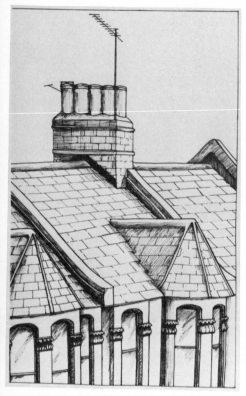
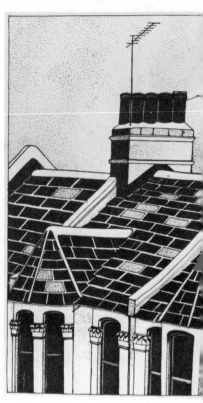

*Linear and tonal interpretation of roofs
and chimneys*

Tone

Tone is the scale from light to its full saturation of any given colour.
Although black and white are not, in fact, colours, our eyes see the
pigments producing these effects and so for our purpose they will be
referred to as colours.

White is the lightest of all and there is no colour darker than black, so
that there will be the longest range of tonal gradations between these two.
On the whole, tone in drawing is thought of as 'shading' or 'hatching'.

Plant forms translated into tone and line by different methods

Tone may be created in many ways according to the tools being used. If an area is covered in small dots placed very close together, that area will appear darker than one in which the spots are farthest apart. So it is with any sort of marks created by the tool. In fact a completely tonal drawing can be created without any 'shading' at all. A variety of marks to give tone in terms of graphic textures can make a drawing exciting, especially where the marks vary in size as well as type. Some of Van Gogh's reed pen drawings show this clearly.

A tonal drawing should have some areas of pure white as well as black, so that there is a sparkle to the work.

91

*Plant forms translated into tone and
line by different methods*

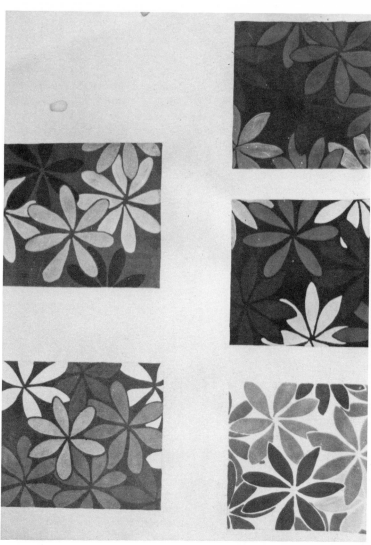

Change of colour schemes effects a change of tone

Painting: freedom and control

Handling paint, in terms of control, can be learnt quite quickly. It is what is done with the paint which becomes more complex and therefore more difficult.

The better we become, the higher are our aims and therefore a greater effort is needed. Any artist who believes that all his work is good, shows merely that his standards are not high enough for his potential ability. This is not to say that we should never be pleased with our efforts. Improvement is achievement and everyone is capable of some improvement. Never assume that because young children take naturally to paint at an early age and make charming images, that this aptitude will either remain or be constant. Nor should an apparently natural handling of the materials prove that there is full control. Young children paint happily within their own limit, no more, as do we all unless encouraged to progress. With young children it is important to encourage them in the right way *for them* and not to impose adult concepts and standards either too soon, or in some cases, at all. Young students should be shown how to control paint, the difference between runny paint and thin paint and they can be shown how to mix to an even consistency, (creamy-thick) which will give full saturation of the colours, (we are talking about powder or block colours for general school use).

Another important thing to realise is that there is a limit to the names we can put to colours. Remedy this by starting students on 'How many different colours can you mix?' (each patch touching the next, so that paint which is too wet or thin can be seen immediately). Then go on to groupings which can be brought about by mixing one colour with another and so on, so that colours will be discovered which may perhaps be described but are without a name. Refer to the section on colour and try some of the sequences mentioned there. Another useful experiment is to start with one colour and work through a family of colours to reach another, so that halfway along there will be a colour which is half-and-half of the two ends. For example, red, through mauve to blue. In fact, do anything which will lead to the discovery of variations of those colours already easily mixed. Colours to indicate mood are useful and help when it comes to creating a personal 'feel' to work.

While the students are learning to mix, keep the lessons simple and do not worry about specific images — these will come when you encourage students to apply what they have discovered. This is where subjects should not be too rigid but should provide an outlet for students' ideas.

Technical hints

It is easier to start light and mix to dark. Dark colours are stronger, so that dark to light becomes difficult. Some powder colours are actually impossible to mix with water – the powder floats. If this happens, then a couple of drops of washing up liquid will do the trick and change the surface tension. Don't be too generous otherwise the paint will froth! Once students have begun to control their paint with sufficient confidence to make an image, suggest and brief on subjects where

1 Colour is of prime importance for some particular reason.
2 The subject itself is not so difficult that it will dominate the efforts of the students.
3 Directly or indirectly it will lead naturally to the next lesson.

Something totally imaginary can be a good exercise as there will be nothing 'correct' to worry about. An imaginary beast (to give a well-worn subject) can be anything to anybody and could perhaps be followed by the sort of place the beast might live in – and with appropriate 'mood' colours.

Points to watch with young students

The thick 'outline' left in and the 'halo' between subject and the rest of the picture. People feel differently about these but you should be sure that you know what *you* feel and deal with them accordingly. If you do nothing at all then these may well become habits which ruin later work and stop students from growing up in terms of approach to work. One other point to consider is whether to allow pencils (drawing) to be used with painting where it's not part of mixed media. I can see only harm in this – since the students will be filling in a shape and the painting will therefore be restricted, losing the quality and scale of paint. Also the training in using a medium with reference to its inherent qualities, will be lost.

As the students progress, paintings and briefings will become more complex, but always take one problem at a time – then later on, several of these could be combined in another lesson. Only the teacher in charge can really know the rate of progress by being sensitive to the attitude and ability of groups as well as individuals within them. Encourage a group to work to its utmost limit so that progress is steady and the more able students will not become bored.

Consider these points

The direction in which brush strokes flow — the thickness of the marks —
the variation of thicks to thins — of large to small — the scale of brush
marks to the subject — the textures created by a mixture of many or a
few marks and whether they are the same size but different directions.
Direction creates movement — this should be considered carefully and
made the subject for experiments. Once students become reasonably
controlled in their work, give them opportunities to express their own
ideas within the framework of the lesson.

Total freedom leaves most people doing nothing at all — this is where the
idea of self-expression breaks down. It should mean that students are
encouraged to have personal attitudes to certain ideas and subjects.

Even in trying to express their ideas they are going to need help in
sorting them out, choosing the right media and then constructive critical
advice along the way. With older students much of this support will
come through back-up work and reference preparation through to the
finished work. With younger ones it could come through choice of
materials or simply a good discussion on what they think about the
proposed problem.

Some work may show the distinct influence of the teacher. Then there
may have been too much direction and not enough room for students to
develop their own styles. The standard of directed work is usually higher
than the more independent sort and it can give the teacher and the
school a good reputation, but it doesn't necessarily help the students.

As for the practical side of painting, make sure that each student has
sufficient room and is free to move about for supplies. This can be
difficult in a small room, but often this situation can be improved by
careful planning. If possible, too, each student should have some space
to put drawings, notes and colour roughs so that they can be used
during work.

However you plan and teach, try to instil a sense of enquiry into your
students so that they grow up with the idea that investigation of
everything is a natural part of their work.

Painted texture

*Close-up of knitting based on the
texture of a natural form*

Printed textile design

Fabric collage

Textiles

Textiles are exciting, capable of changing surfaces, catching the light, expressing ideas as clearly as may be done with any other art media. Students should begin to handle threads, materials and textural forms with ease and be able to see all the possibilities. This will break down their conventional ideas. There should be plenty of odd fabrics from which to choose and students should be encouraged to experiment freely, starting perhaps with straightforward collage. The actual craftsmanship may be taught in stages to introduce various techniques.

Some suggestions for simple beginning

None of these methods needs expensive equipment. For teachers who are not familiar with techniques there are excellent books obtainable through libraries.

Tie-dye For this you will need cotton material, strong thread or string, *Dylon* dyes, a hand basin and gas ring for hot-water dyes or a hand basin only for cold. Hot-water dyes give deeper colours. Salt and soda will probably be needed too. Follow the makers' instructions. Basically, the technique of tying material tightly in different ways prevents the dye from reaching the tied parts, except for a seeping effect into the folds. The manner of tying will create different patterns and different objects, such as buttons, may be tied into the fabric for added effect.

Batik The materials required are Batik wax, fabric, old brushes, a tjanting, a tin for the wax. The tin of wax is put into a saucepan of hot water so as to melt the wax gently. It is then used hot so that it soaks into the cloth to prevent dye reaching the waxed areas. If the cloth does not darken as the wax is applied, then the wax will not have penetrated. It may be applied with a brush or a *tjanting*. The latter is a copper tool (heat-retaining) with which wax is scooped up and applied through the small spout. Very fine lines may be made this way. When the design is completed and the wax dry, it is carefully crumpled in the hand to achieve the crackle effect, and put into a cold dye bath. When the dye is rinsed and the cloth dry, the wax is removed by ironing the fabric between sheets of newspaper until all the wax is gone.

Threads/materials Begin, in advance, by making an appeal to the whole school for old clean clothes, as well as for threads, wools, string. Just imagine if each student in a large school brought just one garment! Jumble sales can produce garments for a few pence. Start the collection by dividing it into cartons (from the local supermarket) by colour grouping. Keep threads separate. Never throw away old tights – they can be cut into strips and used for weaving.

*Experiment in knotting theme with
applied decoration*

Fabrics can be folded, torn, cut, pleated, shredded, padded, embellished
with other fabrics or threads, beads, knots, or sequins. Threads may be
used for line or texture. Use everything as freely and directly as possible
on the same basic principles as for painting, but adapting the ideas to
the character of the materials being used.

Experiments in knotting

Even if your own skills are not sufficient for you to teach the subject in greater depth, at least your students will have enjoyed the experience and may be encouraged to learn more by themselves. The important thing is that they should try to express their own ideas and not be led into the 'kit' world where designs and colours are provided for them.

Real artichoke

Fabric translation of a dried artichoke

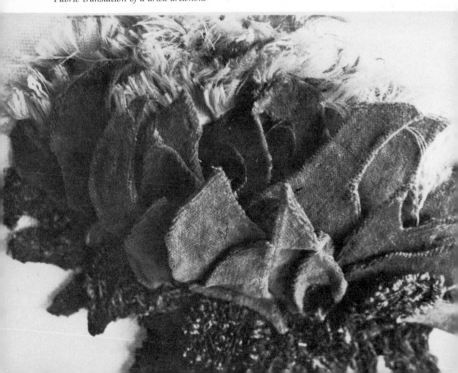

Fabric translation of a half pepper

Soft sculpture is another way of using fabrics. It can be a very personal way of expressing ideas, but you must have a working knowledge of all the techniques if any are to be pursued satisfactorily. It is not good enough merely to copy an object in terms of fabric. For instance, the stuffed, fabric half-a-pepper should not be only that, but an exciting piece of three-dimensional design which expresses the characteristics of a pepper without losing the essential qualities of the fabrics and embellishments used. This is a subtle differentiation but a vital one.

Texture weaving on a notched card

Beginning a shaped weaving, warp made
over a paper design and stretched
around pins stuck into softboard

Free weaving needs pins and a piece of softboard (which can be re-used many times). The pins form the equivalent of the warp and weft threads are simply woven through. Take care, when changing colour or texture, to link over the previous warp thread so that there is no gap.

These techniques may be used with each other and the result combined into group work.

Stitchery will embellish surfaces and create textures. It should be used freely, the stitches built up into areas or layers rather than used in the single lines associated with conventional embroidery. It is preferable to use only one or two stitches in different sizes and types of thread, rather than too many used unimaginatively.

106

Drawing based on a shell

Natural objects: landscape, townscape

For a country teacher the business of using nature in any form as a
starting point presents only the sort of problem with which any teacher
is faced when preparing lessons. The country is there for the students to
feel, smell, observe and wander in – in all seasons, moods, weathers.
Students will probably already be collecting such things as shells, stones
and dried flowers.

For the urban teacher with students living in high rise flats or over-
crowded areas, the problem is enormous. For a start, it may be that few
of the students will ever have seen a garden. I once asked a class of
thirty twelve year-olds, only two actually had gardens and they sounded,
by description, more like backyards, and none of the others seemed to
have any idea of the appearance of a garden. Not one student had any
conception of how plants, bushes or flowers actually grow; they saw
flowers as single units as one might buy them in a shop – without
leaves. The fact that there were flowers, bushes and trees growing in the
school grounds had escaped their notice, probably because these had no
real part in their life unless they were pointed out.

By now you will have realised that no section in this book is, or can be,
complete in itself. This one, for instance, has to be related to the earlier
section on the use of reference. This overlapping is a characteristic of all
art teaching and sooner one begins to think laterally as well as
vertically, the sooner the work becomes more exciting, stimulating new
ideas and ways of thinking.

In teaching any complex subject it is often best to work up to it gradually
so that it becomes a logical expression of the results of investigation into
many varying areas – so long as the work doesn't drag on. Each lesson
should be a discovery, the findings and results should be discussed.

107

Drawing of a head of corn *Painting of an artichoke*

Natural objects

A collection of natural objects is essential to every studio and a good
starting point is to draw or paint from these – but don't let them just
be drawn as pretty things. Try using the following pointers:
Where are they found?
Why are the shells curved in this way?
What once lived in them?
Why do these have spines?
Why do those have patterns on them?
See how this knobbly twig joins the other. Why are they knobbly?
Give students the chance to become curious about the things they draw.
With cut flowers, see if the students can visualise how they grow in
nature – this is where landscape photographs can be used. At the end of
lessons like these you are ready for the next step. If possible, a visit to
the local park should be arranged. Each student should have a notebook
in which to make small drawings of any area which takes their fancy –
but first there should be a joint walk round the park so that their

Sea

Ivy

attention can be drawn to the relevent things – and never allow them to draw an object in isolation as this would perpetuate their fragmented outlook. Even if there is little time, at least a suggestion of the surroundings of the chosen subject should be shown.

Provide each student with a piece of dark card or paper about 16.5 mm × 21.6 mm and cut out a rectangle in the centre 25 mm × 38 mm so that this can be used as a viewfinder to isolate areas. The width of the paper round the hole will effectively block out extraneous matter even when held well away from the eye.

If no park is available, then picture reference will have to be used instead. Let students select several pictures of small areas of vegetation and add things of their own. Alternatively have natural objects and pictures in different groups – perhaps showing seasons – and ask them to discuss colour or mood before putting anything on paper.

Left to themselves they will paint green trees (all the same green), brown tree trunks, bright blue sky, green grass, grey houses with red roofs and bright blue circular ponds.

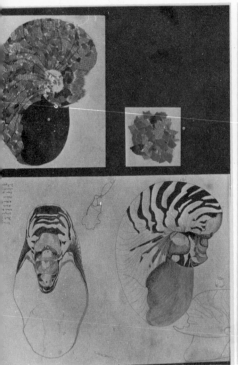

Shells, interpretations of natural forms

You may well say that if this is what they want to paint, and this is how they see things, why should we try to force on them our views? Remembering that this book is directed at teachers of the secondary age range, then the answer to that point is that we don't force our views. But, as art teachers, it is our job to see that students grow up learning more about their visual world – its appearance and structure – than they ever would without our help. We try to prevent them from remaining visually ignorant and unaware for the rest of their lives.

110

Different ways of designing

Painted textures to suggest vegetation or landscape

The most difficult thing of all to 'teach' is the construction of a complete landscape, assuming that students are not painting on the spot. Topographically it involves scale, different levels of distance, possibly some scientific perspective. Most difficult of all, it means 'inventing' the land. From foreground to the mountains that are invariably included, there may well be hundreds of miles of land to express somehow. Overlapping large objects such as trees in the foreground helps, but students even in the fourth year, find it very difficult to understand how things overlap. A lesson given entirely on this subject helps, but it seems to be a difficult concept to retain long enough to help with future lessons – at least until a later age group. One way of coping with this is to encourage layering the distance into different surfaces/textures of vegetation.

Teach the students to break up their paint surface by making use of a variety of brush strokes and colours. This applies to other media as well, such as pen textures, torn paper and so on.

Make sure that pictures start with the background. Left to themselves, students will paint as they think – one thing at a time and separately – so there will be single trees, single houses, a fence and nothing around them. Putting in the background afterwards means that the picture has

Landscape with figures

not been conceived as a whole and that 'backgrounds' are seen as something different from the 'subject'. In many cases there will be unpainted space left all around things – in case anything is spoiled by going over the edge – or hours will be spent painstakingly painting the spaces between branches and fences. There is no one solution to these problems, but to be aware of them is the first step and then it is up to the teacher who knows the students, to devise a way of counteracting these bad habits.

It is easy to get hooked on landscape in a general way but don't forget there are other aspects of the country-side to be explored.

Rural trades and occupations Farms, animals, the people who look after them, etc.

Farm machinery and the seasons in which they are used.

The sort of houses, cottages, barns and other agricultural buildings seen in different areas.

How dry stone walls are constructed, and things like sheep pens.

Cattle auctions.

All these make good subjects if you can find suitable reference as a starting point or can encourage students in their own research. This sort of work could well be integrated with another subject.

Townscape

The same sort of problems have to be faced by the country teacher (and very often suburban ones) when dealing with town subjects. Working on the borders of the East End of London I have found students who had never been 'up to town' — although, of course, they were surrounded by buildings, streets and traffic as opposed to countryside.

Even faced with expressing ideas about their own environment, students will usually prove themselves both unobservant and unimaginative. Buses take them from A to B, houses and flats are lived in, things are used. Observation is not used in these circumstances so the teacher has to start, as in landscape, by encouraging awareness and fresh thinking.

Some teachers work projects to death and students just get bored with the process, but town and country are both sufficiently rich subjects to be served well by this method, if the situation is right for the students. There are so many ways of tackling problems, but one way might be by grouping students, each group researching a certain aspect. At the end of a given time, all drawings, cuttings and information could be pooled and the whole group could discuss how best to use all this visual information. Some suggestions:

A mural.

Booklets (involving the making of the book).

Pictures and words (plus sounds on a tape).

Large individual paintings/collages.

Taped interviews with people in the street, accompanied by small illustrations.

A slide show if film is available.

All these activities could also be brought together as a complete exhibition (useful for parents' days) but in any case it is good to let the school see what is being done in the art department.

Students who lack initiative should not just be sent off and told to 'get reference'. Each group should be briefed very carefully and the whole class should listen so that they know the full picture and aim. This project could occupy at least half a term, so have short lessons prepared for filling in gaps of time or if the weather is not obliging. Try to organise it so that not all of the class is out of the studio (unless you are with them) at the same time. Organisation must depend on the age and character of the class. Make sure you know where everyone is, or should be and if there are such things as rubbings to be made, do warn other members of staff who might be disturbed by weird scratching sounds outside their room.

Man-made sources of ideas for work,
railway station ironwork

The inspirational shapes made by a
bundle of waste material

Another source, the surface of bent corrugated iron

Man-made objects

Shape—function—design basis—working models—structure—balance—form—relation to environment

Still-life

Objects related to one another—spaces between—ellipses—space allowance for form—composition within the frame

The drawing and painting and general use of man-made objects seem to offer an absolute gift for the investigation of many of the basics in art, so this chapter will be arranged under terms and headings rather than explanations and procedures.

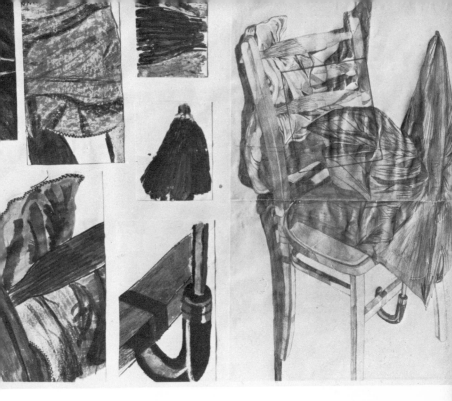

Stages of development in a still life study

Design from a jam jar

Small man-made objects — any chosen media

Always use functional objects rather than decorative ones which might involve 'taste', thereby preventing the object from presenting an impersonal image.

Choose such things as can-openers, clock workings, telephones, hard chairs and so on. Investigate the following:

Shape and shapes between, analysis of design related to function.

Use shapes to relate colours.

Use shapes to make patterns.

Analyse structure and balance.

Design an instruction sheet for using the object.

Use shape as a basis for a lesson on improving the design of the object.

Three-dimensional work Use shape/form — design a functional toy.

Space Design and make a model of a room.

Project Design objects related to an activity, eg, cooking. Use an object such as a teapot or a lipstick and design a package. This will provide an outlet for lessons on lettering.

118

Design from a can opener

Using different media
Cut paper　Shape. Design. Pattern. Repetition. Colour.
Folded paper　Light. Form. Three-dimensional constructions.
Pens/Inks/Graphic tools　Draw. Design. Analyse. Lettering. Design on packaging. Add cut paper for packaging design. (Mount working drawings for the design project.)

Other approaches
Colour　Analyse colour content in the object. Design a fantasy product or something fancy like a perfume container.

Relate to TV/mass media
Advertisements – analyse their specific function and purpose. Look at the titles for different types of programme, adventure, space fantasy, crime and sports programmes. Decide how the titles increase or decrease possible interest and how they express the character of the programme. The subject has no end as a starting point to other things when you have finished using objects directly. Because of the need for man-made objects it will relate to the life of the students.

Still-life

A discipline in drawing or painting groups of objects in such a way that they sit firmly in space and on the surface if the work is to be 'realistic'. If reduced to a two-dimensional plane, then the problem becomes more one of design. In both cases care should be taken to see that students make a good arrangement on their paper and do not have the objects floating about in an unrelated way. The shapes which are left between the objects and the edge of the paper should be an integral part of the arrangement. Make sure that they understand the nature of *elipses* which lie above or below the eye level. Make sure too, that your students understand that if an object has solidity, then space must be allowed for on the 'ground', otherwise distance will not be convincing and objects may appear to be floating halfway up another. This sort of work is also very good as an introduction to thinking of people in a setting.

Still life painting

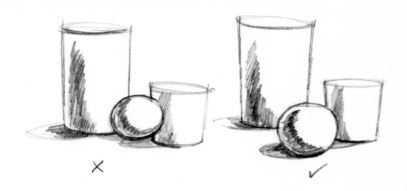

Space allowance for solid objects

Still life painting

S. M

Fantasy and imagination

In dealing with personal experience and visual awareness, it is all too
easy to forget or to dismiss the other side of our perception – that of the
inner self. Theorists maintain there are two sides to everyone – the *visual*
which derives from the environment (outside oneself) and the *haptic*
which is primarily concerned with the body's sensations.

These divisions are more subtle than expressed here and really it is best
to read the work of the authors who put forward these views
(Lowenfeld/Read). But it is mentioned so that teachers may be aware
that, whatever the current theories on teaching art, we none of us
should neglect to encourage all sides of our students' natures, even if it
is unfashionable to do much in the way of imaginative picture making.
If we do neglect the fantasy aspect it means that we penalise the students
who need to have this side of their work developed.

Fantasy plays a part in all our lives although most people fantasise on
their own realities.

Fantasy painting, 'Trees and Creatures'

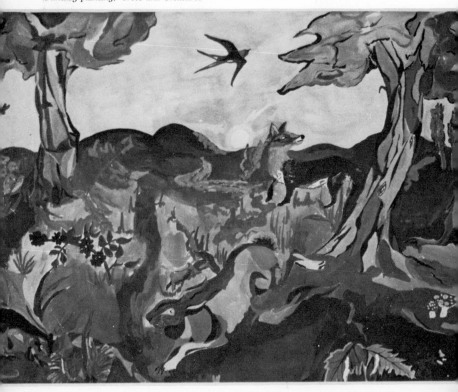

*Technical college student at work on a
fantasy object*

Many teachers build on this and give subjects such as 'Magic Trees' or
'A Fantastic House'. They hope that their students will make a more
imaginative interpretation of a house/tree than the ones they see every day.
Much may be gained from this approach and imaginative treatments can
become very exciting if the briefing is effective.

The approach of 'make something out of your head' is wasted if the
briefing cannot draw out more than the very pedestrian. The student
will produce only what is already in his head — perhaps put there by
watching television or by looking at pictures in books. One student's
dragon or witch will have an almost identical appearance to that
produced by the rest of the class. They will say 'but that's what they
look like'. This stems from a second-hand and mindless acceptance of the
work of established illustrators and artists — accepted as the definitive
appearance of the subject. Sometimes this is understandable — how many
of us can see 'Alice' looking other than the way Tenniel made her, or the
Red Queen either? However, it is our job to try to promote fresh and
inventive thinking.

Imaginative statement on the theme of
'Hunger'

Does fantasy have to have a starting point in fiction/fairy stories, or can it be triggered by simple things like noises, words, colours or activities? We can see that most fantasy has its roots in things experienced – this is so even in dreams – so that changing the usual relationships can begin a train of imaginative ideas.

Place an egg on some straw and it is 'normal', place it under a glass case or next to a diamond bracelet and it becomes something different. An idea such as 'Snow in the Tropics' could be stimulating. A class given a strip story to do on the subject of 'Crossing the Sahara in a Mini' produced some interesting pictures. They had to start by finding out what might really happen – how much petrol, how would sand affect the brakes, heat and tyres, and then build their fantasy on this. There are better subjects but this is the sort of lesson where the teacher has to try to foresee where the snags might come and try to find ways round them so that different stories and pictures may result.

124

Fantasy design rough

Open-ended briefings

The open-ended briefing is one which has to be planned well in advance.
It's movable but can rarely be spontaneous as the teacher must pick a
subject or aspect which can be approached in a number of ways. The
end result may not be reached in the conventional way. Sometimes
there may not even be an end result, as such, but it may lead to a new
beginning. It also involves having all possible materials available to the
students.

Most lessons of this kind start off as an investigation or as a corporate
experiment which may lead in different directions.

The former may be an investigation by individuals or groups into the
nature of some living or natural form; such as the effect of coloured light
on objects or the distortion of various objects by various means. This
briefing would start with the subject and the freedoms are those which
appeal to the individual in the manner in which he decides to approach
the subject. The teacher, then, must have some idea of what is possible
and must be prepared for the unexpected approach in the light of any
discoveries made. Let the suggestions come from the students but be
available to help them decide on their attitude, and the media, size, etc,
of the work they hope to carry out.

In the corporate experiment, everybody joins in first. It may help if I give,
as an example, a lesson given to a group of fifteen twelve year-olds.
They were given several plastic photographic dishes which contained
water with a good squeeze of washing up liquid. They poured coloured
ink into this and blew through straws into the liquid until a great heap
of bubbles rose above the dishes. Then, very carefully, with pieces of
cartridge paper, they scooped up bubbles. When the bubbles burst they
were supposed to leave their coloured imprint on the paper. They did
not – but some students discovered that if the ink were poured very
carefully on to the bubbles in the dish just before scooping off, then it
worked. When all the students had a good number of bubble prints, the
paper was trimmed and all the prints put on a table for a discussion. It
had been fun. Left at this stage it would have been nothing more.

The conversation went something like this:
– What would you do with them now?
– Throw them away.
– Paint them.
– Copy them.
– Interpret them?
– What does that mean?
– If you had all sorts of other materials, what would you do next,
starting from these papers?
– Cut holes in material.
– Tear holes in paper.
– Stick bits of coloured paper on to . . .

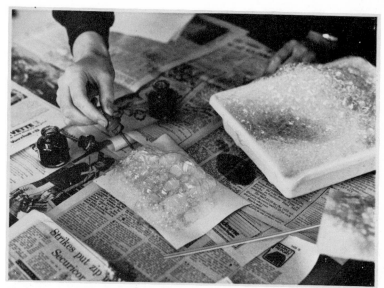

Staining soap bubbles with ink

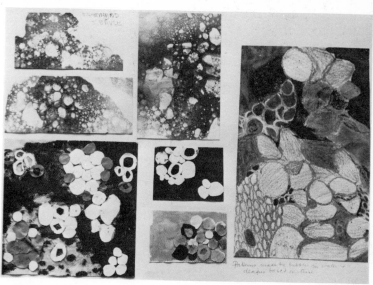

*Work sheet of bubble prints and ideas
developed from them*

127

The discussion went on for some time as it was difficult for a young group to see possibilities at first, but in the end everyone started on something, some simple, some difficult but all different.

The next time this group was given an open-ended briefing they were much more sure of themselves and quicker to make decisions without too much help. I found that they developed during the year and at the end had a much more mature attitude to their work than other groups and showed more initiative and independence. They never sat back and waited for ideas to be fed to them, and they confessed that they had enjoyed it.

It can be stimulating for everyone to see a variety of approaches to the same subject where the suggestions did not come directly from the teacher.

It would be a mistake to have this sort of lesson all the time even if it were possible, since important points of teaching could be missed out which otherwise would have emerged in the normal pattern of lessons.

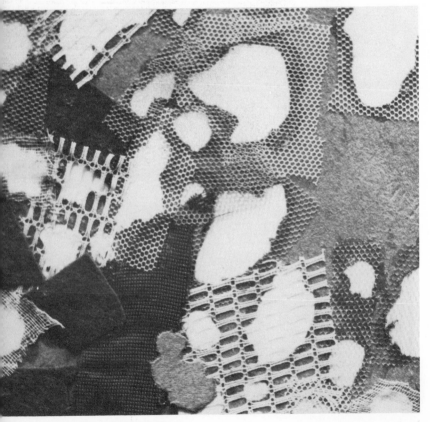

Close-up of a finished work

Thread translation of movement of ink in water

Development of landscape theme

Do what you like with landscape

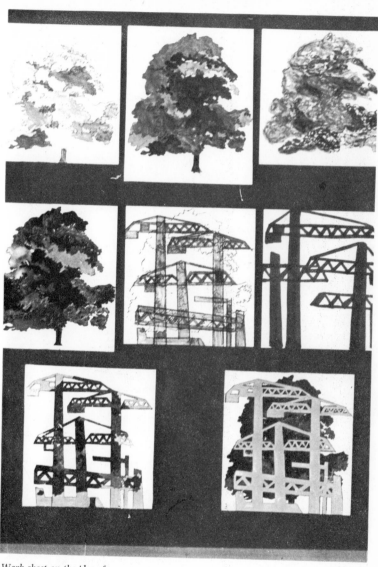

Work sheet on the idea of
machinery encroaching on nature

Music, sound and movement

Ideas do not come solely through things seen but from sounds, movements and things experienced by physical participation, emotional and tactile response. The various stimuli may come from the use of tape recordings, films, records, books, by handling things — not only objects but such things as earth and water — and from the responsive or idea-stimulated movements of our bodies.

The latter tends to make older students self-conscious but younger ones will move naturally.

Here are some starting points

Images say of street fights (aggression) — group action and movement — new and personal images from this — any art activity may result or be teacher directed.

Images of water/snow/elements — words/sounds (crystal, sharp, white, crunch etc) — artwork, action of light on surfaces, pattern texture, illustration of poems written by the group.

Sound (not music) — recordings or live voices. According to the type of sounds the work will vary. Planning the right direction can only be done by the teacher who records or supervises the recordings.

Grating/soft =contrasts.

Sharp/pleasant/unpleasant =texture, mood, colour, etc.

Everyday recognisable =various directions (pictures?)

Sounds can be matched to images, to textures and patterns, actual pictures, weather effects, three-dimensional ideas and so on. (Sparked off by tinkling sounds, this could provide a mobile or a visual toy.)

The possibilities are limitless but must be thought out carefully. Discussion of sounds by the group can be helpful.

Music as music

This is often used for pictorial work but is often used weakly or lazily — letting students move their brushes in a sort of mindless doodling in time to the beat. Music is, in fact, one of the most difficult things to use well. It has to be chosen carefully for the purpose it is to serve.

Some schools have had students illustrate the lyrics of a popular song — as a group — and this can work well as it is a positive thing. But to use it to produce random shapes and colours is to play a game only.

Music for movement

The mood as well as the rhythm suggests movements — lively, soft — and so will overlap with the use of visual aids mentioned earlier.

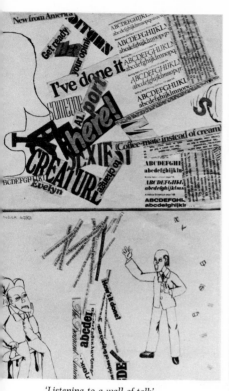

'Listening to a wall of talk' Patterns of rythmns

People: life drawing

The trouble with life drawing is that, in the generally accepted method of teaching it, the figure is totally isolated from its surroundings – students will even draw a seated figure without the seat. Seeing the figure in isolation can not only make the lesson a bore but can destroy confidence – since the attention given to the task will be diverted to the possibility of making 'mistakes'.

In my experience (except in art schools where the function of such drawing varies) the figure should always be related to its surroundings and at first even seen as of less or equal importance – so that the drawing experience may be made more general. The work may be made more interesting by asking a student to pose wearing a striped or boldly patterned shirt or dress. Using cut black and white squares of paper to simulate a chess board floor, it could become a lesson in patterned shapes and relationships – the figure then plays an integral part in the composition.

The form of the figure may well be lost – but this serves the purpose well. If enough experiences of this kind are given them the business of drawing the figure will become more natural and easy. The figure can be related to its 'background' by many other means.

When it comes to 'O' and 'A' level examinations where the figure may have to be dealt with in a more academic way, do not accept pretty, superficial drawing. Any experienced examiner can see through the façade right away. So teach your students to do good structural drawings where the figure is understood rather than just seen – even if the surface work is a bit messy and shows signs of a struggle. The quality of understanding and structure is all important.

With older students, try moving the model during a pose and see that they adjust their drawing to the change. This makes them cross but more aware of the way the figure works. Try also to discourage the use of erasers. If the students cannot rub out they will look harder before committing marks to paper.

Student teachers often ask how to start life drawing. As you see, my answer is you don't – not directly. But in order not to beg the question (and some new teachers will be working with those who believe in the academic approach) here are some suggestions.

Portraits

Let students feel their own head shape; trace their own face shape; feel where their ears and neck join. Use a willing student to help you demonstrate. Point out the subtle shape of the face, where the eyes fit, the relationship of features to face as a whole. The structure of the eyes is important so demonstrate the movements they make. Try all this before starting to draw, then make everyone sit and look carefully from their viewpoint before actually starting. Move in close, try, say, one model to five students so that there are several small groups.

Drawn portraits

Portrait in paint

Portrait translated as part of a painted design

Figure

Make sure that students are the right distance from the model so that the whole figure can be seen in one straight glance. In this case you will be able to have larger groups. Use the same procedure as for portraits – demonstrate with the model first. Start with the poses. Make him or her stand straight; put the weight on one foot; throw out the hip; bend down; curl up into a ball and slowly straighten – all the time pointing out what is happening to the various parts of the body.

Always start with the pose and give perhaps several short ones to draw before beginning on a longer one. Show only the main lines of the pose at first and move on to more detailed work when students can grasp the whole figure idea with some ease.

When dealing with figures in surroundings not in the school, most of us have to use reference of some sort. Collect photographs of people in streets, markets, stations, cafés, and use these to show character, proportion and all the rest. Reference should supplement the sort of things students might see for themselves outside. This is a good chance for a photographic walk if the school has cameras.

Figure painting

Scale, proportion and distance

Teachers who know the rules of perspective think that they should pass them on to their students and those who do not, fret about it and search around for the magic book which will explain all.

One of the least distressing ways of dealing with the problem is not to deal with it as a separate thing but to run a series of lessons (not necessarily consecutively but fairly close together so that they relate) which deal with one small aspect at a time and in an applied way, not just as scientific rules.

It is impossible to advise at what age to start – you must decide when your classes are ready for it. A good indication is when a fair proportion begin to ask about it or show themselves anxious or critical.

I have found that not much understanding occurs before the third year, but this is bound to vary with the type of student.

Here are some suggestions which may be adjusted to suit. The media and actual subjects of the lessons should fit with what has gone before and with what will follow.

Scale

Draw something which is very small/big.

Draw something which is very big/small.

Draw/paint etc a picture with a large object with a very small one near to it, eg a butterfly on a bush or large flower; a mini car alongside a juggernaut/lorry.

Make a picture containing a large and a small object which are not necessarily so in life (large car, small car) and discuss where each might go in order to look as if one is farther away then the other. This will be the beginning of relating to *distance*.

Sometimes, at this stage, it is easier to use cut paper so that the objects can be moved about until a final decision is made as to the best arrangement. This idea may be extended to collage with more complicated subjects – but keep the contents simple in shape although geared to the problem in hand.

This sort of relationship work is best done through personal observation. Place two or three groups of students at strategic points in the playground/street/hall and brief them all to look where the heads and feet of one group are related to those of another.

Let each group take it in turns to observe the others and to move around them at a distance. Observe from a standing position, lying on the ground, and if possible, from high up – eg standing on a table. The students should write down their findings. Then give them some work which will show whether they understand or not.

Do a similar experiment but with observation of the relative heights of students to things in their surroundings – doors, cars, pillar boxes, chairs and tables etc.

Scale and proportions of figures

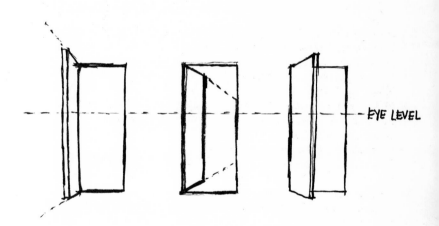

— EYE LEVEL

Eye levels

Deal with observation of building to building. To deal with eye levels and recession, let students hold rulers horizontally before their eyes and check any lines of recession as angles against the horizontal. For example, the lines of doors, curbs.

Open doors can be useful especially if you are lucky enough to have two doors in the studio, both of which open in different directions. The rule is — lines from above your eye level, going away from you, go down and vice versa. This can be seen clearly if a door is opened slowly and the students watch your arm move in relation to the top/bottom of the door.

*Collage of magazine cuttings, showing
varying eye levels*

Scale in materials Most of us think of scale as being related to things in space, but with students of art — especially the younger ones, lack of the knowledge of the scale of tool marks is noticeable. At some time there must be attention drawn to the fact that brush strokes representing grass/bricks or whatever must be made in scale related to the whole. This sort of use of scale should be applied to all work — in texture/collage/stitchery/three-dimensional work. In fact, by the time that students reach the fifth year, they should be aware of all these aspects even if some of them are less resolved than others. Sixth form 'A' level students should then only have to deal with problems in greater depth and with more maturity and this will leave the teacher free to help them develop their own attitudes to the work they are given.

Conclusion

Art is exciting and challenging, it is an education and all subjects relate to it. If we were a hundred per cent successful with our highest ideals we should turn out well-balanced, integrated, perceptive, receptive young people, mature and full of iniative. But we don't. Many of us have to contend with students who have unsatisfactory home backgrounds, with racial problems, conditioning, political machinations, economic problems, the mass media influence and other endless complications. We cannot fully succeed but we should never give up trying for there will always be some successes.

We hear of teachers who actually draw things for their students, who produce templates (and I don't mean just to make a geometric grid), who don't allow paint because it makes a mess and who give out tiny pieces of paper because this size produces neater work. The idea is horrific but it is a fact and it is up to us to alter these attitudes when we meet them. There will certainly be economic restrictions but every teacher should make the most of everything and try to find ways of obtaining cheap materials. Don't weaken. No teacher should give up on discipline either, since discipline and order if applied in a civilised way will lead to freedom and independence.

It is easy enough to write this down but it is often difficult to carry out. Teaching is exhausting and teachers have private lives and problems too. It's trying that counts.

The theorists say that there would be no discipline problems if classes were totally absorbed and interested in their work. True. But who can actually achieve this all the time with every class, every day of every term of every year! If you have the will and the stamina then go on trying but don't turn into one of the easy-way-out teachers.

If you are interested in your subject and become at ease with it in all its aspects (even if you don't want to do much yourself) some of the grind will have gone out of the 'what to do next and how to do it' problem. Art is a communication as valid as speech and more universal than any language.

Plant form translated into line

Bibliography

General

Design and form JOHANNES ITTEN *Thames & Hudson*
Junior School Art KENNETH JAMESON *Studio Vista*
Basic Design: The Dynamics of Visual Form MAURICE DE SAUSMAUREZ
 Studio Vista
Education through Art HERBERT READ *Faber*
Ideas for Art Teachers PETER H GOOCH *Batsford*
Teaching Art Basics ROY SPARKES *Batsford*
Creative and Mental Growth VIKTOR LOWENFELD AND W LAMBERT
 BRITTAIN *Macmillan*

Materials and suppliers

Guide to Craft Suppliers JUDY ALLEN *Studio Vista*

Colour

Colour JOHANNES ITTEN *Thames & Hudson*

Texture

Creative Rubbings LAYE ANDREW *Batsford*

Pattern and shape

Introducing Pattern: Its development and application DENNIS PALMER
 Batsford

Mixed media

Creative Collage IVY HALEY *Batsford*
Creating in Collage NATALIE D'ARBELOFF AND YATES *Studio Vista*

Line/drawing/tone

Drawing Techniques ROBIN CAPON *Batsford*
Landscape Drawing JOHN O'CONNOR *Batsford*
Drawing the Human Head LOUISE GORDON *Batsford*
Creative Drawing: Point and Line ERNST RÖTTGER AND DIETER KLANTE
 Batsford
You can Draw KENNETH JAMESON *Studio Vista*

Painting/printing

Simple Printmaking CYRIL KENT AND MARY COOPER *Studio Vista*
Starting with Abstract Painting KENNETH JAMESON *Studio Vista*

Textile

Design in Embroidery KATHLEEN WHYTE *Batsford*
Embroidery and Colour CONSTANCE HOWARD *Batsford*
Needleweaving EDITH JOHN *Batsford*
Creative Thread Design MAIR MORRIS *Batsford*
Batik for Beginners NORMA JAMESON *Studio Vista*
Creative Appliqué BERYL DEAN *Studio Vista*
Design in Fabric and Thread AILEAN MURRAY *Studio Vista*
Introducing Batik EVELYN SAMUEL *Batsford*

Photography

Photography in Art Teaching ALAN KAY *Batsford*
Introducing Photograms PIERRE BRUANDT *Batsford*
Photography without a Camera PATRA HOLTER *Studio Vista*
Photography for Children MICHAEL PICKERING *Batsford*
The Photo Guide to Home Processing R E JACOBSON *Focal Press*
The Photo Guide to Enlarging GÜNTHER SPITZING *Focal Press*

Paper

All Kinds of Papercraft JOHN PORTCHMOUTH *Studio Vista*
Paper Sculpture STORGE BORCHARD *Batsford*

Clay

Working with Clay and Plaster DAVID COWLEY *Batsford*

Three-dimensional general

Papier Mâché ROBIN CAPON *Batsford*
Creative Papier Mâché BETTY LORRIMER *Studio Vista*
Making Simple Constructions HANSI BOHM *Studio Vista*
Design in Education: Problem Solving and Visual Experience
 PETER GREEN *Batsford*
Exploring Sculpture JAN ARUNDELL *Mills & Boon*
Creative Work with Plaster WARREN FARNWORTH *Batsford*